Byzantium

ROWENA LOVERANCE

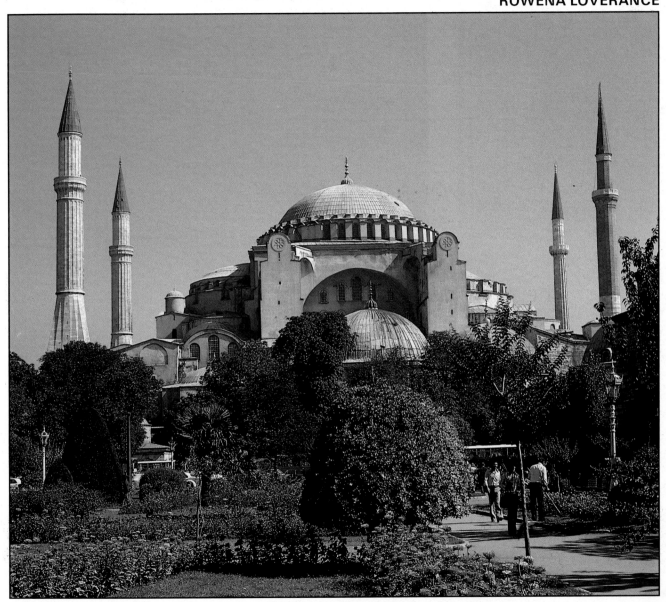

HARVARD UNIVERSITY PRESS
Cambridge, Massachusettes
1988

To my mother

Copyright © 1988 by the Trustees of the British Museum

ISBN 0-674-08972-3

Library of Congress Catalog Card Number 88-539

Printed in Italy

Title page Ayia Sophia, Church of the Holy Wisdom, the Great Church of Constantinople, built originally by Constantine and rebuilt in its present form by Justinian, 532–537.

This page The Projecta Casket from the Esquiline Treasure, Rome, second half of the 4th century. Named after the woman mentioned in the inscription on the rim, this embossed, partly gilded silver casket is thought to have been part of a toilet set given her as a wedding present.

Front cover Detail from an icon of St George (78), mid-13th century, probably painted in the Byzantine style by a French artist during the period of the Crusades.

Back cover Personification of the *Tyche*, Fortune, of Constantinople, a furniture ornament from the Esquiline Treasure, Rome, second half of the 4th century.

Inside front cover Gold bracelet, with a bust of the Virgin *orans* (praying); c.600. The vine scroll which forms the openwork band of the bracelet is a symbol of Christ.

Inside back cover The gilded bronze statues on the west front of San Marco, Venice, transferred there in the 13th century from Constantinople. They originally date from the late Roman period and stood either in the Hippodrome or the main street of Constantinople.

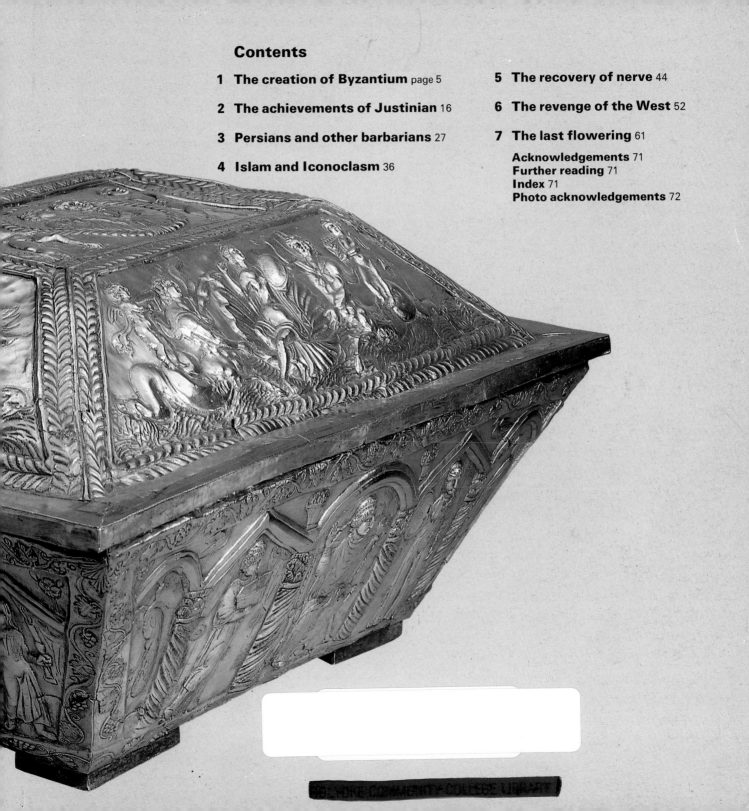

Contents

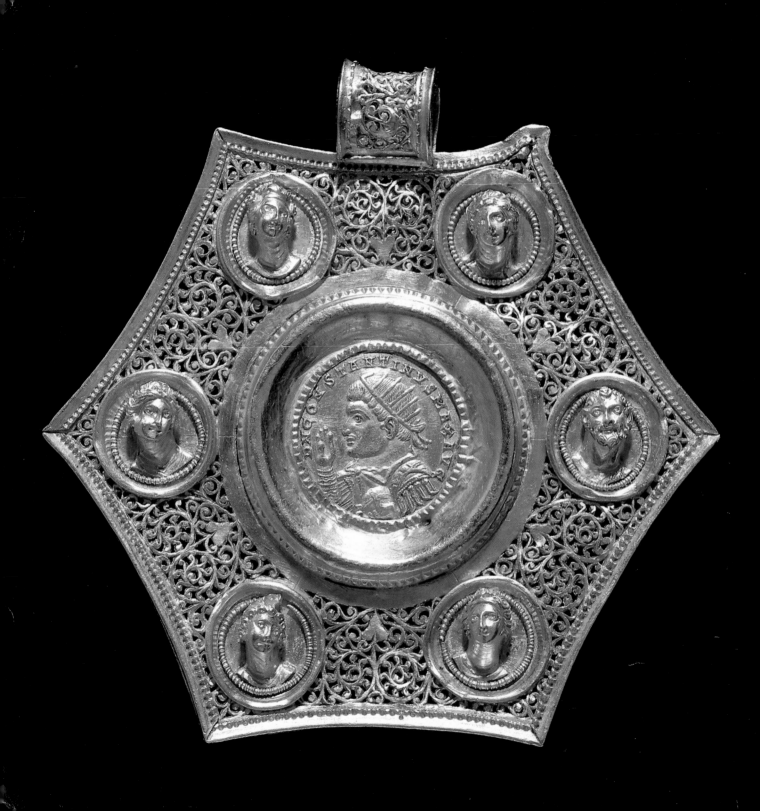

1 The creation of Byzantium

Dimly lit churches with glittering mosaic walls, rows of hieratic figures of unknown saints and martyrs, barely recognisable Christian rituals drenched in eastern exoticism: these are the most frequently evoked images of Byzantium. They are images which have become largely divorced from their historical roots: the empire which flourished in the eastern Mediterranean for over a thousand years from AD 330 to 1453 and of which Turkey and Greece, but also most of the modern states of the Balkans and the Middle East, are in some sense the inheritors.

Byzantium is the name historians give to the Roman Empire in the east, which continued when in the west it fell to the barbarians. Since it is a continuation it has no starting date. Most historians have found it convenient to take AD 330, the foundation of Constantinople, which was to become the capital and symbol of the empire: the city's earlier name, Byzantium, has given its name to the empire as a whole. Others would argue that Byzantium only came into existence after the fall of the empire in the west in the fifth century, with the reign of the emperor Justinian in the sixth century, or even with the collapse of the cities and the classical way of life after the Arab invasions in the seventh century. Whatever one's definition of Byzantium, though, it is essential to remember that throughout their history until the fall of Constantinople to the Ottoman Turks in 1453, the Byzantines thought of themselves as *Romaioi*, Romans, called their city of Constantinople New Rome, and looked back to the classical past across an unbroken tradition.

Constantine I (306–37), the founder of Constantinople, has a pre-eminent place in Byzantine history and memory. In the early fourth century AD the Roman Empire had barely emerged intact from a succession of crises: war on the northern and eastern frontiers against Goths and Persians, economic collapse, imperial impotence. The emperor Diocletian (284–305) had begun the process of recovery; he had created the Tetrarchy, dividing the empire between two senior em-

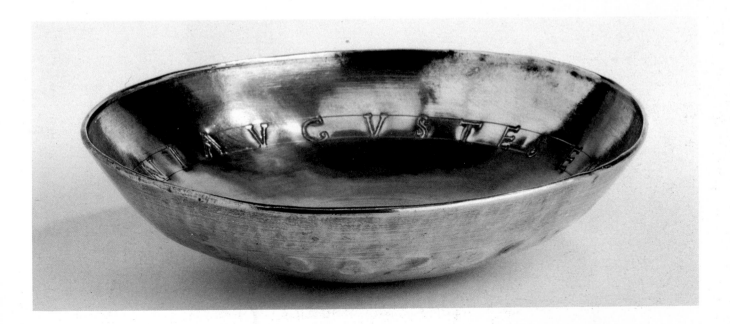

perors, each with a junior emperor to assist and succeed him. Constantine's father, Constantius Chlorus, was the junior emperor who succeeded in the west on the retirement of Diocletian and his colleague Maximian in 305, but on Constantius' death in York the following year Constantine refused to stand aside and had himself proclaimed emperor. He was not the only claimant: the ensuing civil wars went on for eighteen years, and at one time there were no less than six contending emperors.

Constantine's first enemy, as he fought his way across Europe, was Maximian's son Maxentius, who had seized power in Rome and whom he defeated outside the city at the Battle of the Milvian Bridge in 312. He then ruled for some years in harmony with the emperor in the east, Licinius, whose optimistic wish expressed on a silver dish he issued to his troops in 317 for another ten years of rule was, however, to be thwarted by Constantine's ambitions. In 324 Constantine made war on Licinius and defeated him in a sea-battle in the northern Aegean, thus becoming undisputed emperor of the whole Roman world.

Diocletian's doomed attempt to abolish inheritance by birth as a principle of succession and to replace it with nomination by merit foreshadows many later Byzantine struggles with this problem. Constantine proclaimed his dynastic intentions from the outset: in 321 during the struggle with Licinius, he issued a gold coin, a double solidus, to proclaim the

3 The emperor and his family presiding over the chariot races in the Hippodrome at Constantinople. This carved base, late 4th century, stood on the central *spina* of the Hippodrome supporting the Egyptian Obelisk; it shows the emperor Theodosius and his two sons Arcadius and Honorius.

joint consulship of his two sons Crispus and Constantine II. They appear on the reverse; on the obverse the emperor himself is shown with the crown of sun's rays, which recalls his early devotion to Apollo.

It was during the campaign against Licinius that Constantine spotted the site for his future capital, and he built it as, in one sense, a victory monument. He was not the first Roman emperor to think about moving the seat of government from Rome to the east. The incentives were obvious: Rome's inland site was increasingly unpractical and Italy increasingly indefensible; the Balkans and Asia Minor were now the main source of recruitment to the Roman army. Constantine's move became permanent simply because it was an inspired choice. The site, perched between Europe and Asia, was almost impregnable, surrounded on three sides by the waters of the Sea of Marmara, the straits of the Bosphorus and the deep river estuary called the Golden Horn. Byzantium was already there, founded in the sixth century BC as part of the colonising movement which left Greek cities scattered along the coasts of Asia Minor, southern Italy and the Black Sea, and named after its legendary founders, Byzas and Antes. The Roman Empire had also already left its mark: the Hippodrome, extended by Constantine, had originally been built in the second century AD. Constantine extended the plan of the city to include a five-mile length of the peninsula, with its seven hills which recalled those of Rome. Constantinople took six years to build: its foundation was celebrated on 11 May 330.

Constantinople's pre-eminence was only gradually acquired during the fourth century, and only confirmed by the loss of Rome in the fifth. Rome kept its institutions of government, its consuls and its senate, and was adorned by some of Constantine's finest buildings. One insight, though, into the shift of emphasis which had occurred by the mid-fourth century can be gleaned by examining a set of Roman family silver which was discovered on the Esquiline Hill in 1793. The family who owned it is easily identified, since their monogram is 5

Map showing the principal places mentioned in the text. The territory of the Byzantine Empire expanded and shrank dramatically throughout its history according to military pressure from its neighbours. Many lands, even when lost militarily to Byzantium, remained under her cultural influence.

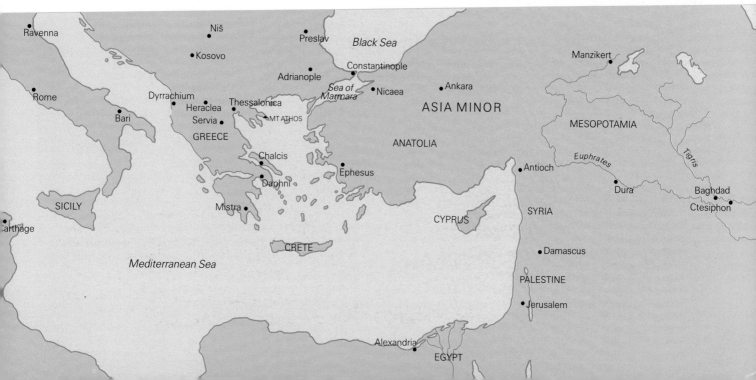

4–6 Group of objects from the Esquiline Treasure, Rome, second half of the 4th century.

4 (*Right*) One of a pair of silver furniture ornaments.

6 (*Far right*) Rome and Constantinople: two of the four silver-gilt furniture ornaments in the form of personifications of classical cities. They probably decorated a ceremonial sedan chair.

5 (*Below*) One of four silver rectangular dishes. The monogram spells Pelegrina and Turcius: the name Pelegrina also appears on a ewer in the Treasure.

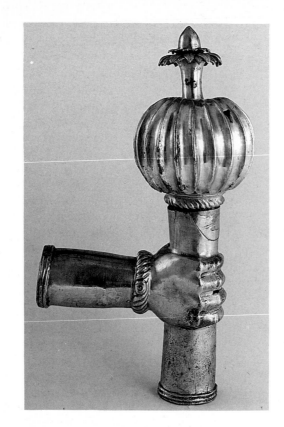

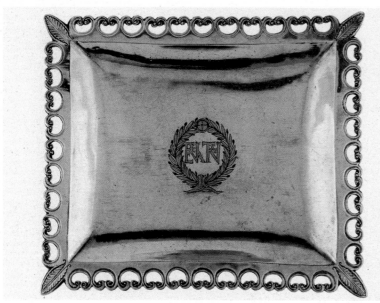

blazoned over the plates and dishes. Members of the Turcii family are known from literary sources to have held high public office, two as Prefects of Rome. That they held themselves in high esteem is clear from the sheer scale of the find, and the appearance of two unusual furniture ornaments, presumably fitting on to the sides or tops of chairs, which are in the form of a heavy fist holding a floral staff, objects unknown elsewhere but clearly evoking authority. Four more furniture ornaments are in the form of Tyches, female personifications of the great cities of the classical world. Rome is an embattled figure, resting on her shield, her lance in her hand, but Constantinople holds a cornucopia, a horn overflowing with fruit and grain, the Roman symbol of plenty. In reality, of course, Constantinople would have to withstand even more sieges than Rome, and would be just as dependent as Rome had been on imported foodstuffs – but in the mid-fourth century she seemed to represent a secure future for the empire.

Constantinople was already distinctive in another way, which was to characterise it throughout its history: it was a Christian city. This, too, it owed to Constantine. In 312, before the Battle of the Milvian Bridge, Constantine saw a vision in the sky of the sign of the cross inscribed with the words 'By this sign, conquer'. He duly painted the sign on the shields of his soldiers and won the battle.

Christian communities, with a high level of internal organisation, such as their own bishops, were already in existence in many parts of the Mediterranean world by the fourth century: their success had provoked a severe persecution by Galerius and Diocletian. There is no suggestion, though, that they formed anything other than a small minority of the population, and so Constantine's religious policy after 312 falls into that select group of actions by an individual that really have set subsequent history on a radically different course.

Constantine began by proclaiming religious toleration for the Christians and restoring church property which had been confiscated. He gave privileges to his Christian subjects, and he launched straightaway on a programme of church building. But changing a state religion is a vast undertaking: in 320 when the Colosseum was struck by lightning Constantine was obliged to agree to the usual rites of divination to reassure public opinion. The creation of Constantinople thus gave Constantine an opportunity to start from scratch, in a city that was expressly Christian and where three great churches, the Holy Wisdom (Ayia Sophia), the Holy Peace (Ayia Eirene) and the Holy Apostles, formed an integral part of the design.

Before Constantine Christian communities had largely worshipped in house churches, such as the famous third-century example excavated at Dura, in Mesopotamia. Constantine's architects had to create an entirely new building, the Christian church intended for large-scale public worship. They turned to a secular building type, the Roman basilica, a high vaulted hall, often with aisles and galleries, which was used for large public gatherings. A particularly fine example, the Basilica of Maxentius, was under construction in the Forum at Rome when Constantine took the city in 312, and he adopted it to his own use. The basilica became the standard Chris-

tian building type for the next three centuries, and examples are found throughout the empire in the principal cities – the original St Peter's in Rome was built in the 320s – and in the remote provinces. Its use was not uniform: there was still scope for more unusual ground-plans, particularly for churches built as mausolea, such as that for Constantine's daughter, the S. Constanza in Rome. None of the earliest churches of Constantinople have survived: the Ayia Sophia and Ayia Eirene were of basilica plan, but were remodelled in the sixth century by Justinian; the Holy Apostles was probably on a cross plan, but has disappeared altogether.

Constantine was particularly interested in identifying and marking with churches the sites in the Holy Land associated with the life of Jesus. He built churches at Nazareth and Bethlehem, and in Jerusalem at the Mount of Olives, the site of the Ascension and the Transfiguration. His treatment of the site of the Holy Sepulchre has determined its whole later history: once the rock-cut tomb had been identified, by criteria which are not recorded, the surrounding rock was cut back and a huge circular church of the Anastasis, Resurrection, built around it. This rotunda and central tomb form the core of the many reworkings which the Holy Sepulchre has undergone, and the central Christian image of the tomb, spread by pilgrims' accounts and by rough sketches

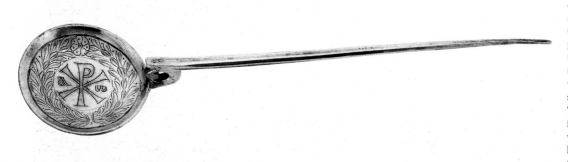

7 Constantine used several versions of the cross as Christian symbols. The cross of his vision was probably the *crux monogrammatica*, which appears on the Projecta Casket (9), but the most popular version, known as the Labarum, was the *chi-rho* (the first two letters of the word Christ in Greek). On this spoon from the Carthage Treasure, late 4th century, it is surrounded by a victory wreath and flanked by the letters alpha and omega, Christian symbols of the beginning and the end.

on pilgrim tokens, is found on a wide variety of early medieval art objects.

Christianity was benefiting from a high level of imperial patronage, but the process of altering the institutions of state religion took a long time. From 361 to 363 the emperor Julian, the last member of the dynasty Constantine founded, attempted to re-establish the pagan cults, and it was not until 392 that pagan temples were officially closed and pagan worship in public and private forbidden. The process of private acceptance was equally protracted. Objects in the Esquiline Treasure (p. 7) may again suggest both the means by which conversion could be effected, and yet how easily pagan and Christian ideas co-existed in the mid-fourth century. The central item of the treasure is a large embossed silver-gilt casket: it takes its name from Projecta, the woman addressed with her husband Secundus in the inscription on the lid and shown in the central panel. The portraits and inscription suggest that the casket is a wedding gift. The form of the inscription *Vivatis*, 'May you live (in Christ)', and the accompanying cross symbols make it clear that the couple were either Christians or Christian sympathisers; since a member of the Turcii family of the previous generation is known to have been a member of one of the pagan colleges of priests, it is possible that it was Projecta who was responsible for introducing Christianity into the family. The casket is after all presumably intended for her use when she went to the baths: the back panel shows just such a bath procession, while the front panel shows a woman at her toilet, a theme which is echoed in the scene of Venus at her toilet on the lid. Venus was still an appropriate companion at her bath for the Christian Projecta.

If the Esquiline Treasure reflects a moment of transition, an ivory plaque from about 400 may refer to one of paganism's best-recorded last stands. The ivory, half of a diptych, was presumably issued to mark a funeral; impor-

8 (*Above*) Ivory panel, *c*.420, one of four forming the sides of a box, showing scenes from Christ's Passion. The tomb here appears as a typical Roman mausoleum, with Corinthian capitals and lion-head door-knockers; the open door was already used in late Roman art to symbolise the passage from death to life.

9 (*Below*) Projecta Casket from the Esquiline Treasure, Rome, second half of the 4th century (see also contents page).

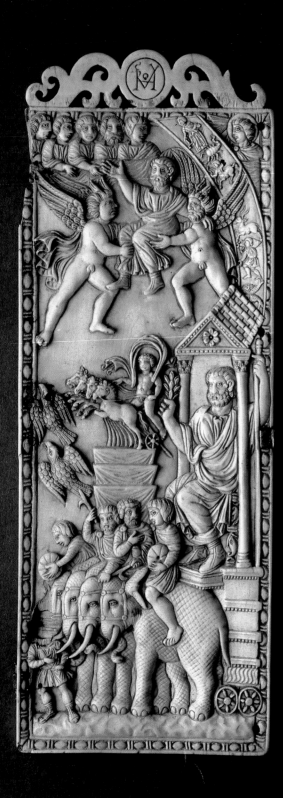

tant Romans also issued similar ivories to mark their year as consul. It is packed with pagan symbolism on each register: the team of elephants drawing the funeral carriage, the triple pyre from which eagles are loosed and a god rises in a four-horse chariot, and the raising of the deceased figure to the heavens by two genii, perhaps representing Death and Sleep. Most of these elements can be paralleled in imperial apotheoses from Augustus onwards, but the piece is characteristic of fourth-century philosophical thought in applying all this imagery of the afterlife to the fate of the individual soul. The central figure is not an emperor, but a senator; the monogram deciphers as that of the Symmachi. Quintus Aurelius Symmachus, Prefect of Rome in 384/5, led the outcry against the removal, from the Senate House in the Forum at Rome, of the Altar of Victory commemorating Augustus' victory over Antony and Cleopatra at Actium in 31 BC, arguing that Rome could not afford to break with the faith of her ancestors. This ivory, then, if it commemorates Symmachus' death in 401/2, clearly uses an appropriate range of symbolism. Symmachus lost his fight, and the altar was removed; Rome, though, was sacked within a generation by the Visigoths. The need to answer the inevitable question, why conversion to Christianity had brought the city to material collapse, was the spur to the writing of that great work of Christian apologetic, St Augustine's *City of God*.

Pagan cults thrived on variety, but for Christianity the problem of orthodoxy versus heresy was present from the beginning, and from Constantine's conversion onwards the

10 Ivory panel, half of a diptych, *c*.400, showing the apotheosis (carrying up to heaven) of a Roman senator. Note the sun and the symbols of the zodiac in the upper right-hand corner.

state was called upon to judge between rival claims. In 325 it was in order to pronounce on the status of one of these heresies, Arianism, that Constantine summoned and personally presided over the oecumenical Church Council which was held at Nicaea; this was the first of seven such Councils held before the eastern and western Churches began their long drift apart, whose formulations of Christian doctrine are thus accepted by both the Orthodox and Catholic Churches. Arius, a monk from Antioch, struggled with Christ's significance within the Trinity, and argued that since the Son proceeded from the Father, he must be in some sense less divine. The tenets of the Nicene Creed which emerged from the Council, 'begotten not made', 'Very God from Very God', are thus intended to confirm Arius' beliefs as heretical and to assert the full divinity of Christ.

Not all the fourth-century heresies were theological in origin. The first one with which Constantine had to deal derived from the previous period of persecution, and the feeling that the mainstream Church had collaborated with its persecutors. In North Africa each group refused to accept clergy who had been ordained by bishops of the other party, and this soon led to two separate church structures, with the Donatists taking their name from Donatus, the 'pure' bishop of Carthage. Constantine was unsuccessful in resolving this problem: the struggle was still being waged fiercely a century later at the time of Augustine, who as Bishop of Hippo led a campaign against the Donatists from 393 onwards. This may be the context for the burial of the Carthage Treasure, another group of silver dishes which bear the name of a high-ranking late Roman family, in this case the Cresconii. It was one of the Cresconii who took the imperial letter to Symmachus appointing him consul for 391. The Cresconii were apparently pillars of the Orthodox Church in North Africa, and another member of the family was Bishop of

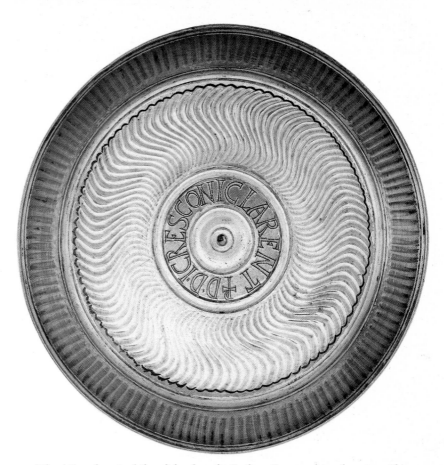

11 (*Above*) One of a pair of silver dishes from the Carthage Treasure, late 4th century. This one is inscribed with the family name, Cresconii; the other has the injunction *loquere feliciter*, 'talk happily'.

12 (*Below*) Two bowls from the Carthage Treasure; the lids could also be inverted to use as dishes. These elegant bowls are among the finest examples of late antique silver.

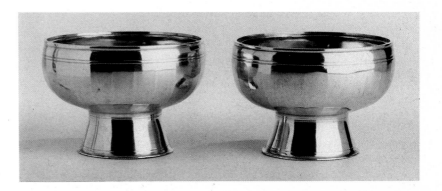

13 Ivory openwork panel, 5th century, showing Bellerophon killing the Chimaera, a fire-breathing monster with three heads. This Greek myth was used by Christians to express Christ's triumph over the powers of evil.

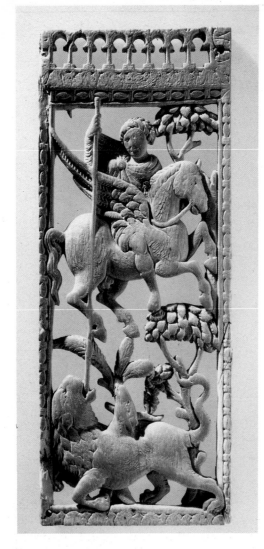

14 (*Below*) Marble sarcophagus, *c.*300, illustrating the story of Jonah. On the left the sheep hovering in the sky presumably indicates that the artist was copying from another sarcophagus where the Jonah theme was combined with that of the Good Shepherd. The holes bored in the sarcophagus date from its use as a garden trough in the 18th century.

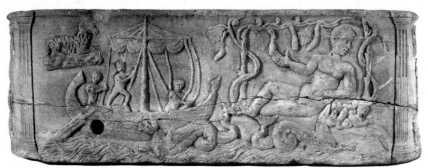

Cuicul (Djemila) when a new basilica was built there to celebrate the return to the fold of some former Donatists in 411. The burial of the Carthage Treasure may relate to this period of violence between the two communities, or may date from a generation later when the Vandals entered North Africa in 429. The fragmentation of North African society caused by this long-running ecclesiastical dispute was probably a major reason for the Vandals' success.

If early Christian architecture was practically a creation of the fourth century, early Christian art had an established tradition before Constantine, and can be well studied in the wall-paintings of the Catacombs at Rome, and the baptistery of the house church at Dura. Constantine's conversion and the end of persecution inevitably brought changes in the function and explicitness of Christian art, but like the process of conversion itself, they are slower to make themselves felt and are only gradually emerging by the end of the fourth century.

A huge marble sarcophagus from Italy is a fine example of late antique art immediately before Constantine, about 300. The promise of resurrection is firmly conveyed by the use of the story of Jonah. Jonah at first disobeyed God's instructions: he thus serves as an appropriate symbol for man's sinful ways. Having been thrown overboard by his fellow sailors, he spent three days and nights in the body of a whale, an obvious foreshadowing of Christ's Passion; the final scene shows him reclining under a gourd tree sent by God to protect him from the heat of the day: an image of Paradise. Jonah features in many media of early Christian art; in the Catacombs at Rome, the mosaic floors of the basilica at Aquileia, and in lamps and glass vessels. His use on a coffin is particularly appropriate, and the deeper meaning of the story is further stressed by the appearance on one end of a peacock, another symbol of eternal life.

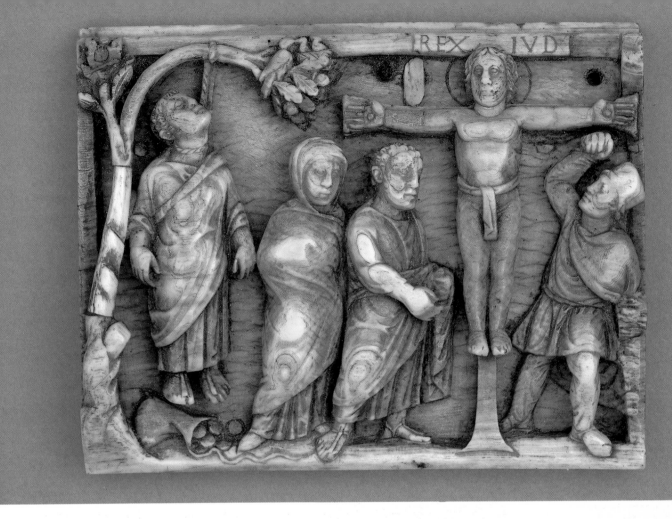

REX IVD

15 Second of a series of four ivory panels, c.420, with scenes from Christ's Passion (see also 8).

8, 15 By the end of the fourth century the need was less for such symbolic, hidden representations, but rather for an explicit narrative rendering of the Christian story. Four ivory panels, forming the sides of a box and probably made in Rome about 420, are among the earliest surviving examples of this new development in Christian art. They show scenes from the Passion of Christ, from Pilate washing his hands, through to Christ's appearance before doubting Thomas. The narrative element could hardly be stronger; details even include the cock and the thirty pieces of silver. But there is still no attempt to treat the scenes naturalistically: Christ's body rests statuesquely on the Cross rather than hanging from it. Before this, though, the Crucifixion had never been represented realistically. This ivory is therefore the earliest known narrative representation of the Crucifixion in Christian art and in its almost aggressive certainties looks forward to the first golden age of Byzantine achievements.

2 The achievements of Justinian

Constantine had founded a new city and had given the Roman Empire a new state religion, but his reign had not changed the essential character of Roman life. The Mediterranean world was still undivided, city life and a money economy still flourished. The first of the blows which were to thrust Byzantium into a new and more dangerous world was delivered in the fifth century, with the succession of barbarian invasions which eventually brought about the fall of the Roman Empire in the west. After 476 Byzantium was left to stand alone.

The 'barbarians', a name originally coined to mean anyone who could not be understood because they did not speak Greek, and applied here to a range of Germanic, Slavic and Turkic tribes living in central and eastern Europe, were a familiar phenomenon to the Romans. They had been settled for many centuries on the Rhine and Danube frontiers of the Empire, and had long formed a necessary and valued part of the Roman army. There was, however, always pressure on them to cross the frontier into the richer lands of the Mediterranean, and from about 375 onwards this pressure became irresistible, with the arrival in Europe of the Huns, a nomadic tribe from the Asian steppes. Some tribes stayed to form part of a loose Hunnic 'empire', others started on the long search to find lands to settle within the Roman Empire. The Visigoths were the first to make their presence felt, defeating the Roman army at the Battle of Adrianople in 378 less than one hundred and fifty miles from Constantinople itself and killing the emperor Valens. His successor, Theodosius I (379–95), used a tactic which many subsequent emperors were to copy, and with a mixture of force and bribery moved the Visigoths out of the Balkans and into Italy. Instead of threatening Constantinople, they sacked Rome in AD 410.

Though the shock to contemporaries of the sack of the ancient city can hardly be over-estimated, it had little immediate political effect in Italy or in the east. The two halves of the empire had been divided in 395 between Theodosius' two sons, Arcadius and Honorius, and this division was to prove permanent. Honorius had already moved his seat of government in the west to Ravenna, and Roman rule continued there for another sixty years. This was the first of Ravenna's great periods of court life, which has left such monuments as the Mausoleum of Galla Placidia, Honorius' half-sister. One by one, though, the western provinces were settled by the barbarians: southern Gaul and Spain by the Visigoths, North Africa by the Vandals; the overthrow in 476 of the emperor Romulus Augustulus by a barbarian general, Odoacer, is generally taken by historians as marking the end of Roman government in the west. Italy itself was soon occupied by another Germanic group, the Ostrogoths, whose leader Theodoric also made his capital at Ravenna.

Byzantium had not been unaffected by these fifth-century developments in the west. There was a long period of political weakness as the practice of hereditary succession to the throne came under strain: Theodosius II, Arcadius' son, was only six years old when he inherited and his sister Pulcheria had to rule as regent; thereafter on several occasions the succession

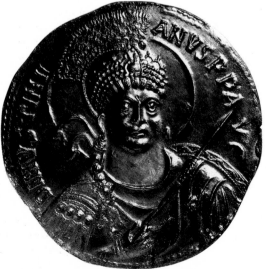

16 The emperor Justinian, hailed in Latin as Augustus and Father of his Country; electrotype of a gold medallion, now lost, issued by the mint of Constantinople, c.534.

17 Silver bowl from the Carthage Treasure, late 4th century. On the rim and in the centre are chased hunting and pastoral scenes, alternating with classical profile heads.

18 Detail of marble table from Thera (Santorini), showing the same range of pastoral imagery. Fragments of such tables are a frequent find on church excavations from the 5th to 7th centuries. Now in the Byzantine Museum, Athens.

had to be passed on by the marriage of an emperor's widow or daughter to a promising general (Zeno) or administrator (Anastasius). The eastern empire also shared the military threat posed in the middle of the century by the Huns under Attila, who raided freely and extorted huge sums in subsidies. It was in response to this threat that the great land walls of Constantinople were built in 447. Constantine's city had already expanded beyond his original plan and his walls, which have not survived, proved inadequate. The Theodosian walls were more than a mile further out, and the massive tripartite system of inner wall, outer wall and moat set standards of fortification which were hardly equalled in antiquity. They were not breached by force until 1453.

The fifth century in the east, then, is a story of precarious survival, but by the end of the century military and economic stability were beginning to return. The emperor Anastasius I (491–518) especially, by his reform of the coinage and the taxation system, was largely responsible for creating the enormous financial reserves which were to fuel Justinian's achievements.

Justinian came from a peasant family in a remote part of the Balkans, a village called Bederiana, which may be located near Niš in modern Yugoslavia. He owed his advancement to his uncle, Justin, who came to Constantinople to seek his fortune and who rose through the army until he was in a position to succeed Anastasius in 518. Justin was already old and needed his nephew's support. Justinian became co-emperor in 527 and sole emperor from his uncle's death in 529 until his own in 565. For almost fifty years, then, he held supreme authority in the empire.

His reign is above all characterised by ambition. To an extent this is an obvious development from the constraints of the previous century: the eastern empire's greater material prosperity would find natural expres-

sion in an artistic and literary revival. But the astonishing range of achievements of Byzantium in the sixth century seem to have the unity of purpose which reflects the character of Justinian himself, and stems directly from his conception, both philosophical and practical, of the nature of the Roman Empire.

It was a conception that was at once classical and Christian. A gold marriage-ring which dates from the end of the sixth century perfectly expresses the vision which fired Justinian: the heavenly couple, Christ and the Virgin, are blessing the human couple, over an inscription *Omonoia*, 'Harmony' or 'Concord'. The classical personification of Concordia often featured as a patron of marriages. In the Christian world too harmony is a divine quality: it exists in Heaven, and the Empire serves to reflect it on earth. Christ embodies the heavenly harmony; the Emperor is his living representative. The ring thus conjures up the threefold spheres, human, imperial and universal, which make up the Byzantine world view.

Justinian inherited a Roman Empire which was no longer universal: he thus saw it as part of his imperial responsibility to restore it to its ancient bounds, and he had the financial and military wherewithal to attempt the task. The resulting wars of conquest, together with more defensive wars against Persia, took up most of his reign. He began in North Africa, where his chief general Belisarius arrived in 533 with a small force. Not the least of Justinian's qualities was his ability to pick the right men, and Belisarius was one of the most effective instruments of his policies. The Vandal kingdom was conquered within the year, though guerilla warfare continued, and Belisarius moved on to Italy in 535. The Ostrogothic kingdom, though in political disarray after Theodoric's death, proved a tougher opponent. The fall of Ravenna in 540 allowed Justinian to start the building of churches (San Vitale and Sant'Apollinare in Classe) intended

to eclipse those of Theodoric, but the final submission of Italy took all of Byzantium's resources and was not achieved for another fifteen years. Meanwhile, a third front was opened up in 550 in Spain, where a Byzantine army recovered the south-east corner of the peninsula.

Thus by Justinian's death a substantial part of Byzantium's fifth-century losses had been restored. Just as the *Omonoia* ring expresses the philosophical unity of the empire, on a more prosaic level the ubiquity of other items of Byzantine jewellery expresses the material unity which Justinian's reconquests had achieved. It was a short-lived unity; a second wave of barbarians, the Lombards in the west and the Slavs in the east, were to pose even greater threats to Byzantium before the end of the century, but for a brief moment the classical shape of the Mediterranean world seemed to have been recreated.

In most ways that affected the lives of people in the eastern empire, the character of the classical world had never been lost. The urban population went about its business under an unprecedentedly high level of centralised state control. Justinian himself created a new state monopoly, one which was to bring great wealth and prestige to Byzantium, when he despatched two monks to China to discover the secret of silk production: they returned with silkworm eggs hidden in a hollow stick. This freed Byzantium from the high transport costs and customs dues of importing silk through Persia, and a careful system of preparing the raw material, production and sale was evolved, every stage being under close state control. Fragments survive from the early centuries, mostly from the dry soil of Egypt, but later Byzantine silks became prized diplomatic gifts, and are found in many important western European treasuries.

Silk is not closely datable, but the state control of some other media has proved very useful to art historians. Byzantine silver, for

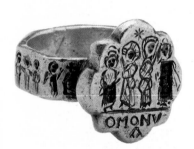

19 Gold marriage ring *c*.600. The seven scenes on the hoop are from the life of Christ, but the craftsman seems not to have been sure of the story: the Adoration of the Magi and the Presentation in the Temple appear in the wrong order.

20 Panel of silk from the sleeve of a tunic, c.650–700. Found in Egypt and probably made in Egypt or Syria. The Greek inscription 'of Zacharias' is likely to refer to the silk-weaving workshop, since the same inscription is found on a number of similar panels.

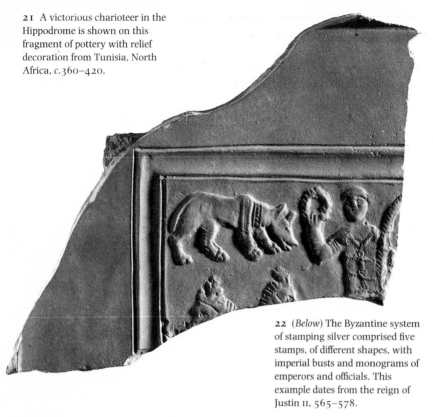

21 A victorious charioteer in the Hippodrome is shown on this fragment of pottery with relief decoration from Tunisia, North Africa, c.360–420.

22 (*Below*) The Byzantine system of stamping silver comprised five stamps, of different shapes, with imperial busts and monograms of emperors and officials. This example dates from the reign of Justin II, 565–578.

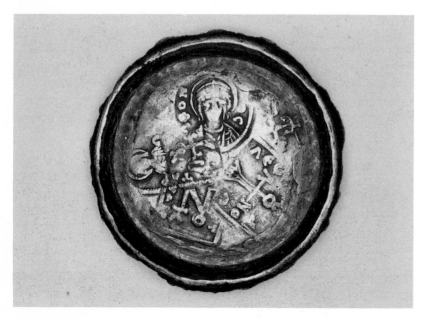

instance, in the sixth century and early seventh was subject to a system of multiple stamping, which allows us to date pieces not only to the emperor's reign, but within that to the tenure of office of the relevant financial official. The respect which the system commanded is demonstrated by an episode in the life of a seventh-century saint, Theodore of Sykeon in Asia Minor. The saint sent his archdeacon to Constantinople to buy a new silver chalice and paten, but then refused to use the offending objects despite 'the perfect and well-wrought workmanship and the quality proved by the five-fold stamp'. Further enquiries established that the silver had been derived from the chamber-pot of a prostitute, a rather successful one, presumably.

One of the most successful prostitutes in history is another star character of Justinian's reign, his wife Theodora. Her life, both in its origin and its most famous incident, witnesses another aspect of classical city life still flourishing in sixth-century Byzantium, the life of the Hippodrome and the amphitheatre. The circus factions of Byzantium – the Blues and the Greens – were originally organised to support teams of charioteers and other performers required in these public entertainments, but they had developed into the main outlet of popular moods and discontents, and their composition reflected differing social standings and religious affiliations. Theodora was an actress, and the daughter of a bear-keeper employed by the Green party, but she herself was a life-long supporter of the Blues, and it was through them that she met Justinian. Their marriage took place in 525; it required a special edict, since senators were forbidden to marry actresses.

The Greens and Blues were not always locked in mutual rivalry: the most dangerous occasions were when they were united against the government, and one such occurred in Constantinople in January 532 in response to high levels of taxation and a government

attack on administrative corruption. The crowds in the Hippodrome turned to rioting and chanting the slogan *Nika* (Win), which they used to urge on their teams. The government lost control of the city for several days, and large areas, including the Great Church, the Ayia Sophia, were completely destroyed. A rival emperor was proclaimed, and Justinian for once lost his nerve and suggested flight. Theodora's retort reported by his historian Procopius, 'There is the sea, and yonder our ships. But for me, purple makes the best winding sheet', deservedly saved the day. Belisarius and his army invaded the Hippodrome and restored order, after killing some 30,000 people. The only popular attempt to dethrone Justinian had failed, and by the end of his reign the influence of the circus factions, both in Constantinople and the provincial cities, was on the wane.

Other legacies to Byzantium from the classical past were more cohesive. They included a knowledge and appreciation of classical literature, which was to be the motive force of Byzantine scholarship. One example can stand for others: the tradition of pastoral writing which had stayed in vogue from Hesiod's *Works and Days*, through Alexandrian authors like Theocritus, to Virgil's *Georgics* and *Eclogues*. Artistic references to the popularity of pastoral imagery abound in a variety of media, such as a silver dish from the Carthage Treasure, or a marble table which probably stood in a church to receive the offerings of worshippers. Ivory containers *(pyxides)*, may also have had a religious use to hold the elements of the Eucharist, but may nevertheless feature the same lolling shepherds, complete with pipes and cymbals to divert their flocks. And on the mosaic floors of the Great Palace in Constantinople, the only part of this elusive building to have survived, the pastoral theme apparently appealed equally to imperial fantasies. Nor is this only an artistic conceit. A family sitting down to dinner in sixth-century

Asia Minor could pick up inscribed spoons which, like a modern cracker, reminded them of famous maxims from antiquity. And here, too, Virgil's *Eclogues* are well represented: 'Love conquers all: let us too yield to love. Eat, love-struck one'.

Ironically, it was Justinian who was responsible for closing down the last surviving centre of pagan learning, the University of Athens: love of classical antiquity did not extend to the actual teaching of pagan philosphy. The emperor took a close personal interest in theological matters, but it was the religious dimension of his vision of universal harmony which was the hardest to achieve; indeed, it proved beyond him.

The line between orthodoxy and heresy had not become any easier to hold in the two hundred years since Constantine. By excluding Arianism the Church had asserted Christ's divinity, but how was this combined with his human nature during his life on earth? It was hardly possible to find a balance between conflicting alternatives: the Antioch Church stressed the human nature, Nestorianism, while the Alexandrians replied by stressing the divine (single) nature, Monophysitism. The compromise position, that Christ was both fully human and fully divine, was defined at the fourth oecumenical Council of Chalcedon in 451.

The argument also involved the significance

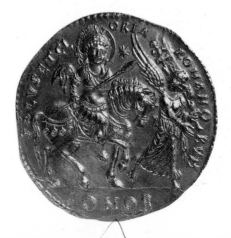

23 On the reverse of the gold medallion (16) Justinian is shown on horseback preceded by a figure of Nike, Victory. The medallion is thought to have been struck to celebrate Belisarius' defeat of the Vandals in North Africa.

of the Virgin Mary, and the Council of Ephesus in 431 confirmed her title of Theotokos, Bearer of God. From then on the image of the Virgin and Child became a hugely popular one in Byzantine art – it features as the prominent apse decoration in most Byzantine churches. An early example is a sixth-century ivory from Syria or Egypt, which combines an image of the Theotokos surrounded by angels and Magi with a narrative scene of the Nativity in the zone beneath. In both of these provinces, though, feelings against the Chalcedonian compromise continued to run high.

Justinian was determined to establish orthodoxy by force if necessary, but was hampered in this by Theodora's openly expressed Monothysite beliefs and her willingness to harbour heretics – even in the imperial palace. Later in his reign, after Theodora's death, he tried making concessions instead: at the fifth oecumenical Council at Constantinople in 553 some theological works of which the Monophysites disapproved were condemned, but this only laid the eastern Church open to the anger of the west. Justinian's quarrel with Pope Vigilius over this so-called 'Three Chapters' controversy was the first of many splits which were over five hundred years to force the eastern and western Churches apart. In this, as in later episodes, theology and politics were inextricably bound: the Papacy had not yet developed its claims to supremacy as the successor of St Peter, but Rome, the ancient capital, was still the burial place of Peter and

51

25 (*Right*) Ivory *pyx*, round box, with pastoral scenes, from Egypt; 6th century.

24 (*Below*) Shepherds watch their flocks on a floor mosaic from the Great Palace, Constantinople. These fragmentary remains are now displayed in situ in a new Mosaic Museum in Istanbul.

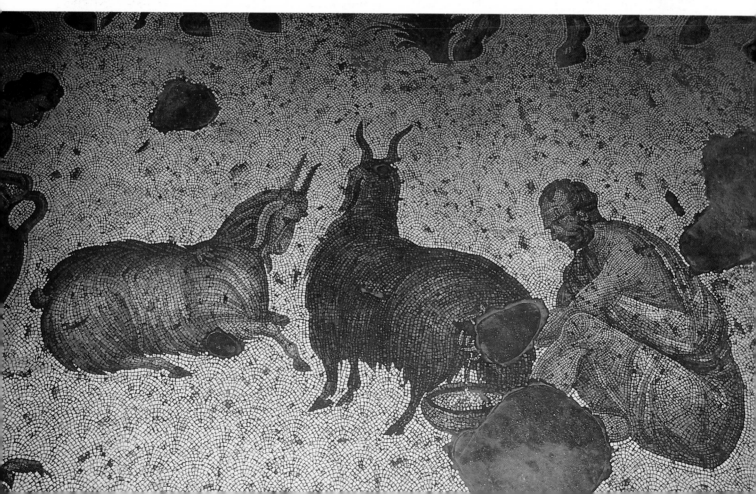

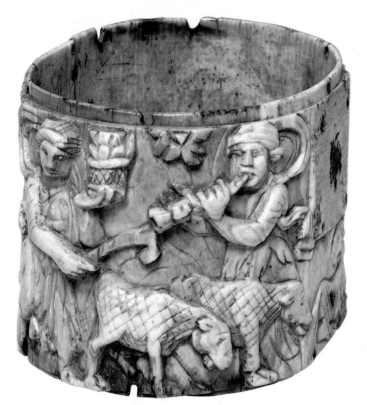

27 Gold glass fragments like the above, probably the bases of glass bowls, are found mostly in 4th-century funerary contexts in Rome. This one shows the Roman martyrs saints Peter and Paul as youthful, unbearded figures.

26 Spoon from the silver treasure found at Lampsacus in Asia Minor and dated to the second half of the 6th century; presumably one of a set of twelve, which have quotations from the Seven Sages of ancient Greece as well as Virgil's Eclogues.

Paul, and Justinian's treatment of Pope Vigilius, who was brought to Constantinople and imprisoned until he submitted, alienated many in the west.

It is Justinian's church buildings which are his real gift to the Christian 'oecumene' which he hoped to establish. His fortifications are equally famous, and he also combined the two functions as in the fortified monasteries at Daphni outside Athens and St Catherine's, Sinai, a community which went back to the earliest days of monasticism. But throughout the Mediterranean, whether on small islands or in the great cities, there is a wealth of churches, some standing, some known only through excavation, which date from the reign of Justinian and which reflect in architectural terms the same soaring ambition which characterised all his designs.

Many of the churches, especially in the 39 west, are in the basilica form which had been established by Constantine, but with a lavish use of marble in the columns and capitals, setting off a range of coloured stones against fine, white Proconnesian marble from the Sea of Marmara. An ivory of the archangel 28

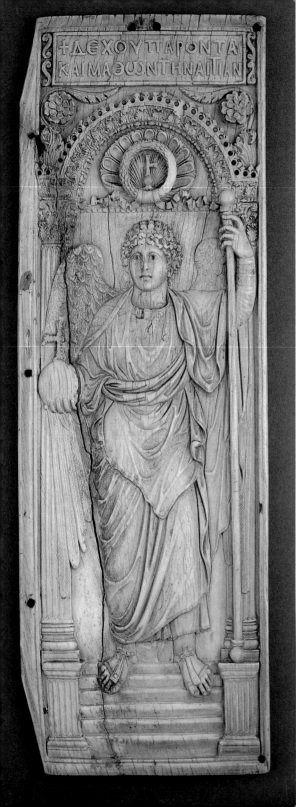

Michael, one of the finest to survive from the sixth century, reflects this wealth of decoration in the architectural framework surrounding the central figure.

Basilical churches had pitched rooves: Roman architects had long known how to build domes, but not how to fit them on to square or rectangular buildings. Justinian's architects rose to the challenge: at Philippi in northern Greece they attempted, unsuccessfully, to cover one bay of the basilica with a dome; in centrally planned churches like SS. Sergius and Bacchus in Constantinople they used an octagonal central core which gave the dome greater support. Their masterpiece was the new Ayia Sophia, started after title page the *Nika* riots in 532 and finished in 537, though so ambitious was it that the dome partially collapsed and had to be rebuilt between 558 and 563. The church was intended to be extraordinary, and it was; indeed, it still is. Inside the basic basilica plan is a central core of four huge piers linked by arches and supporting triangular curved pendentives, which provide a base for the dome. The vast space thus created is made even greater by adding layers of semi-domes at the east and west, and allowing glimpses through the core into the aisles and galleries which surround the main space. The dome, pierced along its 29 base with a host of windows, seemed to contemporaries to be floating from the heavens, rather than supported on the structure beneath. The whole building, with its accumulation of complex elements in total proportion, was the perfect embodiment of the Byzantine world view, with human, imperial and universal spheres bound together in eternal harmony.

The impact of Ayia Sophia depended on the Byzantine appreciation of light. Today the church is denuded of its furnishings, but enough lighting devices have survived from sixth-century Byzantium to give some impression of how it would have appeared in use. A

28 This ivory panel of the archangel Michael is remarkable for the size of the elephant's tusk, as well as for its richness of decoration. The Greek inscription 'Accept these, and having learnt the cause . . .' gives it an enigmatic quality, and one can only speculate whether the emperor himself was the recipient, whose image would have appeared on the lost half of the diptych.

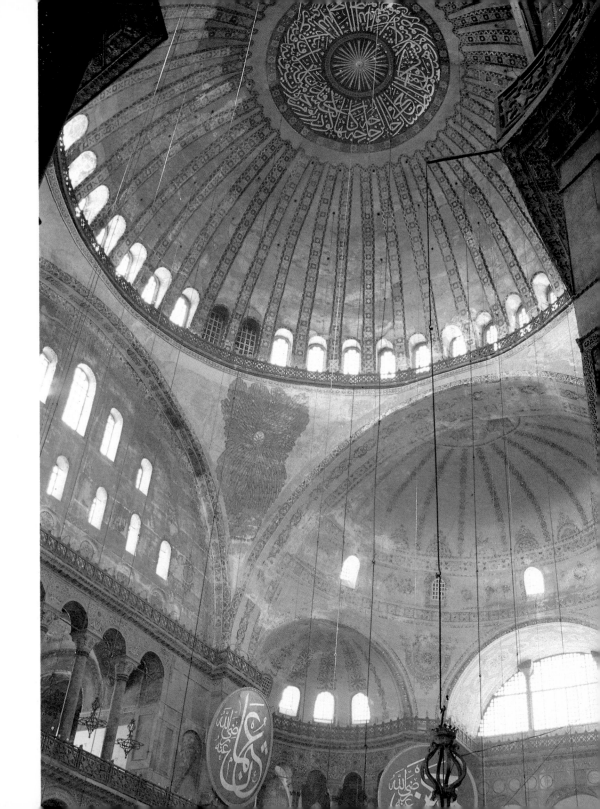

29 The interior of Ayia
Sophia, Constantinople.

30–32 Three objects illustrating Byzantine lighting methods: **30** (*left*) a bronze polycandelon, hanging lamp, 6th–7th century; **32** (*bottom right*) a silver stand for a lamp, *c.*545–565; **31** (*bottom left*) a *menorah*, a seven-branch candlestick, shown on a bread-stamp.

Lamp-stands in silver are rare; this one, from the Lampsacus Treasure, is one of only two known.

Bread for both religious and secular uses was often stamped; this stamp is from Sardis in Turkey and is inscribed 'of Leontios'.

silver lamp-stand is a rarity; more common are polycandela, silver or bronze hanging lamps in which glass cups would have held the oil and wicks. The *menorah*, or seven-branched candlestick, is normally associated with Jewish worship, but it seems to have been adopted into Byzantine imagery as a way of representing the Virgin, Vessel of the Eternal Light. Worship through the eyes came naturally to the Byzantines, but this was to plunge them into serious theological controversy, as the Iconoclast controversy in the eighth century was to show.

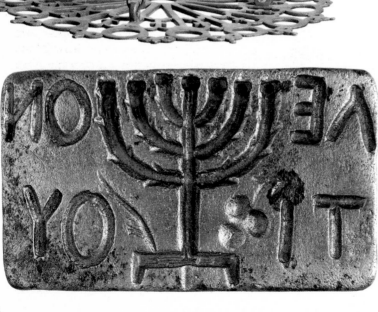

3 Persians and other barbarians

33

When Justinian expelled the pagan philosophers from Athens in 529 they took refuge in Persia, at the court of new Great King, or Shahanshah, Khusro I, whose reputation for justice and for his wide reading of Plato had already reached Byzantium. This latest exchange was a remarkable indication of the long co-existence of the two great powers of the ancient world, the Mediterranean-based city–states of Greece and Rome and the vast Persian Empire, which extended from Mesopotamia to India. The final severing of this relationship in the early seventh century was one of the events that marked the passing of classical antiquity.

Over the thousand-year period different ruling groups, Achaemenids and Seleucids, Parthians and Kushans, had dominated the Persian Empire. The Sassanian dynasty was founded in AD 224 by Ardashir I, who met the challenge of ruling his huge empire by setting up a strong central government, backed by moral as well as political authority. The Sassanians revived ancient Persian religion and social structures, and aimed to restore the empire to the geographical spread which it had enjoyed under the Achaemenids.

Ardashir, a notable warrior, achieved this degree of expansion, but later kings were less successful, particularly in the fourth and fifth centuries, when Central Asia was subject to the same wave of nomadic attack which had brought the Huns to central Europe. The Hephthalite Huns, who in the fifth century controlled a large empire based on Afghanistan, inflicted a heavy defeat on the Sassanian king Firuz in 484: the entire Sassanian army was destroyed, the king killed and an annual tribute levied. Memories of this national catastrophe, inflicted by northern barbarians and compounded by years of drought, famine and internal anarchy, were still vivid at the beginning of the following century.

On their western front the Sassanians were almost constantly at war; they inherited from the Parthians a hostile relationship with Rome, and the disputed frontier in northern Mesopotamia and long-standing rivalry for control of buffer-states like Armenia were standing pretexts for war. The Sassanians at first benefited from the chaos of the Roman Empire in the third century and Shapur I (242–73), Ardashir's successor, celebrated a triple triumph over three Roman emperors. However, Constantine strengthened Byzantium's eastern frontier, and in the 360s the emperor Julian invaded Mesopotamia, reaching the walls of the Sassanian capital, Ctesiphon. His death there from wounds raises a 'what if?' of military as well as religious

33
34

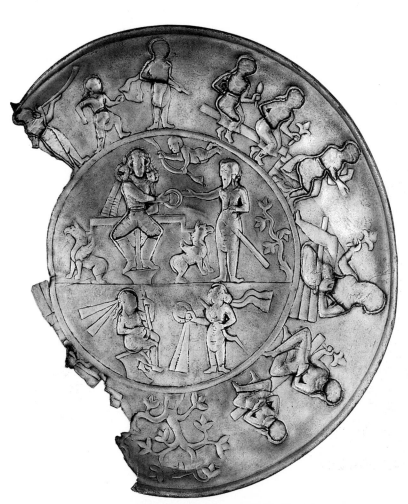

33 Silver dish, 4th century, showing the religious basis of Sassanian royal authority: in each of two investiture scenes a seated divine figure, perhaps Mithra and Anahita, lesser gods of the Persian pantheon, holds out a diadem to a standing human figure.

period, the sixth/seventh century, is even more indisputably Roman, both in its shape, in the treatment of its decoration – the bosses round the neck are a common feature on late Roman tableware – and in its subject matter, an embossed vine scroll inhabited by birds and a fox and naked boys harvesting grapes.

Textiles provide the best example of the relationship working in the other direction, since Sassanian control of the eastern trade routes meant that many luxury materials reached Byzantium only through Sassanian hands. Certain motifs, such as griffins and winged horses, which appear on textiles from Egypt and pass from there into the Byzantine repertoire, are probably Sassanian in origin. Moreover, the technical advance represented by the invention of the draw loom, which allowed patterns to be mechanically repeated and even inverted to create opposed figures, seems to have been made in Sassanian Persia and transmitted via Egypt to Byzantium.

Khusro I Anoshirwan ('of the Immortal Soul'), came to the throne in 531, though like Justinian he had already exerted influence in the previous reign: he had ordered the execution of a religious zealot, Mazdak, and his followers, who had been stirring up revolution by preaching a primitive form of communism. News of this had presumably not reached the Athenian philosophers, who arrived in Persia at this time. Their enthusiasm for Khusro did not apparently survive a closer acquaintance, but when Khusro negotiated a peace treaty with Byzantium the following year, one of the conditions on which he insisted was that they should be allowed to return home without being persecuted for their beliefs.

Justinian used this so-called 'Eternal Peace' of 532 to embark on his western reconquests; Khusro needed it to start the programme of internal reforms with which he strengthened his country after its fifth-century catastrophes. The reforms were remarkable both for their breadth of vision and for the speed with which

35 (*Above*) Silver dish showing the Triumph of Dionysos; Sassanian, 3rd century. The high-relief details, originally including the head of Dionysos, were hammered from a separate sheet and attached.

34 (*Left*) Many Sassanian silver dishes show royal hunting scenes: each king is recognisable by the slightly different crown he wears. His military shortcomings did not prevent Firuz adopting this vain-glorious pose, on this 5th-century dish.

history: his successor negotiated humiliating peace terms and withdrew.

This military relationship was not, however, at the expense of a more fruitful, artistic one: Sassanian silver uses a range of motifs borrowed directly from late Roman art. From the beginning of the period, a third-century dish in high relief has Dionysos being drawn along in triumph, followed by Herakles with his club and lion's skin; Dionysos' panther is drinking from a jar below. The characters appear with all their correct trappings, but the car on which Dionysos is drawn is not exactly functional, and it is clear that the Roman borrowing has not been fully understood. A silver vase dating from the end of the

36 (*Above*) Fragment of rug or wall-hanging found in Egypt, but possibly Persian in origin. Made of wool in tapestry weave, 5th–7th century.

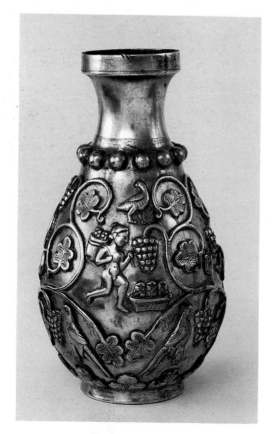

37 This Sassanian silver vase, 6th–7th century, has a decidedly Roman feel in form and in the treatment and subject matter of its decoration. The base is pierced like a strainer.

they were set in motion, but even a high-minded ruler such as Khusro could not dispense with military success. In 540 he launched a surprise invasion of Syria, and succeeded in capturing Antioch, bringing Belisarius back in haste from Italy. His main aim was probably to boost morale and gather booty, an aim which the sack of Antioch certainly achieved, but he also extended Persian territory west of the Euphrates. He undoubtedly gained more satisfaction, though, from his total defeat of the Hephthalite Huns who had wrought such havoc the previous century. He had allies in this task – Turks who had recently come to live north of the Oxus. It is a reminder that movements among the steppe peoples still continued, and were to cause further trouble for Byzantium in the next century.

Like Justinian, Khusro benefited from a long reign, but external and internal stability collapsed on his death, with attacks by the Turks and an internal revolt. Khusro's grandson, Khusro II, eventually had to enlist Byzantine support to fight his way to the throne in 591. Like his grandfather, Khusro II Aparvez (the Victorious), was to survive in folk memory in Iran, but with a very different reputation. He was famous for the luxury and extravagance of his court life, and for the fiscal extortions which financed it. Accounts of royal hunts which involved hundreds of birds and animals with a supporting cast of thousands of falconers and slaves are well borne out by the evidence of the rock reliefs at Taq-i Bustan. His love for the beautiful Armenian princess Shirin, for whom he built the last great Persian palace at Qasr-i Shirin, inspired the great Persian love story, *The Romance of Khusrau and Shirin*, which was retold by many famous Persian poets. Shirin was a Christian and Khusro's policy of religious toleration for the many Christian communities in the Persian Empire was one of the more attractive features of his reign.

38

Khusro's indebtedness to Byzantium had led to a lull in the Byzantine–Persian wars, but in 602 the murder of the Byzantine emperor Maurice by a usurper, Phocas, released Khusro from his obligations. He launched another round of invasions of Syria, Armenia and Asia Minor which this time seemed to be intended as wars of conquest rather than raids for booty. Even more than his predecessors, Khusro Aparvez was determined to recreate the glories of the Achaemenian Empire. Antioch and the other Levant cities fell in 612, Ephesus and the cities of Asia Minor in 615, Alexandria and the rest of Egypt in 619. Despite Khusro's reputation for toleration within the empire, the conquests took on a religious dimension when Jerusalem fell in 614, and the True Cross, discovered by Constantine's mother Helena, was carried back in triumph to Ctesiphon. The shock of this event echoed round the Mediterranean world just as the sack of Rome had done two centuries before.

For the eastern provinces of Byzantium the Persian invasions marked the final break with the secure world of classical antiquity. In the Balkan provinces the break had already taken place. Even during the reign of Justinian the Balkans had been threatened by various Turkic peoples, nomadic Bulgars from the steppes, and much of Justinian's defensive building programme had been directed against their raids. In the second half of the sixth century a new danger arose, that of an alliance between nomadic and more settled peoples. The more settled people were the Slavs, historically well attested but archaeologically difficult to identify, who seem to have moved south in large numbers from the river valleys of central and northern Europe. In south Russia they can perhaps be identified with the culture group who owned the Martynovka Hoard, a collection of silver jewellery whose decoration bears out the agricultural interests of this essentially pastoral people. The

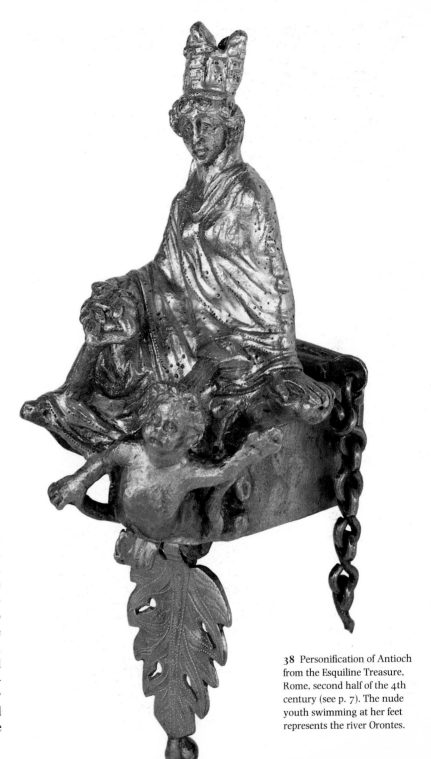

38 Personification of Antioch from the Esquiline Treasure, Rome, second half of the 4th century (see p. 7). The nude youth swimming at her feet represents the river Orontes.

40 (*Far right*) The surviving remains of the castle of Servia, on the river Aliakmon in northern Greece, date from the 13th–14th century, but the site takes its name from the Serbs who supposedly settled there under Heraclius, and the town was the seat of a Byzantine bishop in the 9th–10th century.

nomadic group under whose influence the Slavs fell were the Avars, one of the fiercest of the Turkic peoples to emerge from the Asian steppes, who had left a trail of destruction from as far afield as China. Their horse burials and characteristic jewellery make them easily identifiable, and though relatively few in number, they seem to have exerted a military hegemony over the more numerous Slavs. 42

The two groups crossed the Danube in the 580s and seized a succession of Balkan towns and cities, reaching far south into the Peloponnese, until only a few coastal territories were left in Byzantine hands. There was considera- 39

39 The sanctuary of the smaller basilica church at Heraclea Lyncestis, near Bitolj, Yugoslavia. The Byzantine town was sacked by the Ostrogoths in the late 5th century; in the 6th century a Slav settlement was built over the remains of the theatre.

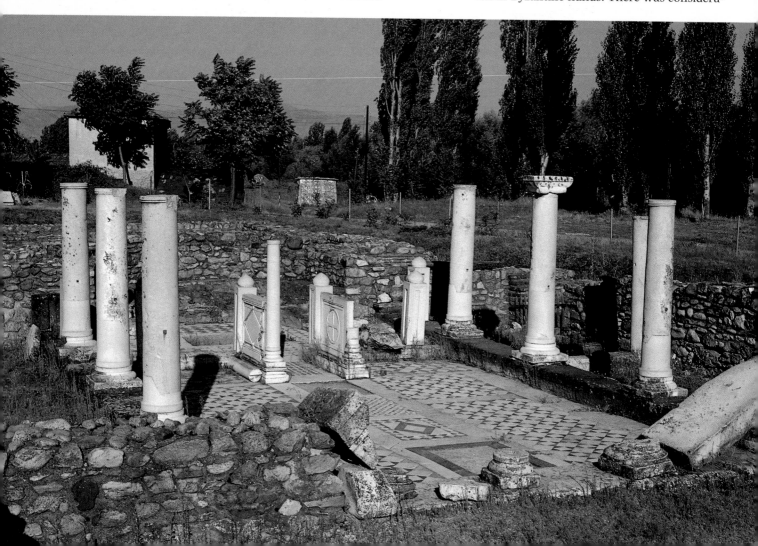

ble resistance at first, especially under the emperor Maurice in the 590s, but when Phocas seized power in 602 he no longer attempted to hold the Danube frontier, and the pace and density of Avar-Slav settlement greatly increased.

The city of Thessalonica was one of the few that held out in the face of sustained barbarian attacks. Its citizens credited the city's survival to the efforts of their patron saint Demetrius, believing that he fought on their side on the city walls and rescued them from starvation during the siege by diverting the corn supply from Constantinople. The saint's popularity, strengthened by these crises, was to remain high in Thessalonica and in the Byzantine world as a whole. A gold and enamel reliquary, though dating from a much later period, well expresses the faith which the saint inspired. The hinged enamel plaque shows St Demetrius lying in his shrine; it opens to show the same scene in embossed gold. The inscription round the edge, '(your servant) prays to have you his keen defender in battles, anointed by your blood and balm', refers to the blood and oil which continued to issue from his shrine, and the whole construction of the reliquary is witness to the belief that, though dead, the saint was still alive. The city believed it had been saved only by supernatural protection, a belief which the whole of Byzantium was soon to share.

The emperor at this time of multiple crises is one of the most elusive characters in Byzantine history, Heraclius (610–41). This is largely because the tradition of writing history ceased in Byzantium at this point, another casualty of the break with the classical past, and from now on modern historians have to pick their way among the medieval melée of chroniclers and poets, panegyricists and hagiographers, all writing for quite a different purpose than to provide information. In the case of Heraclius there are panegyrical accounts of his eastern campaigns, but little record of his domestic

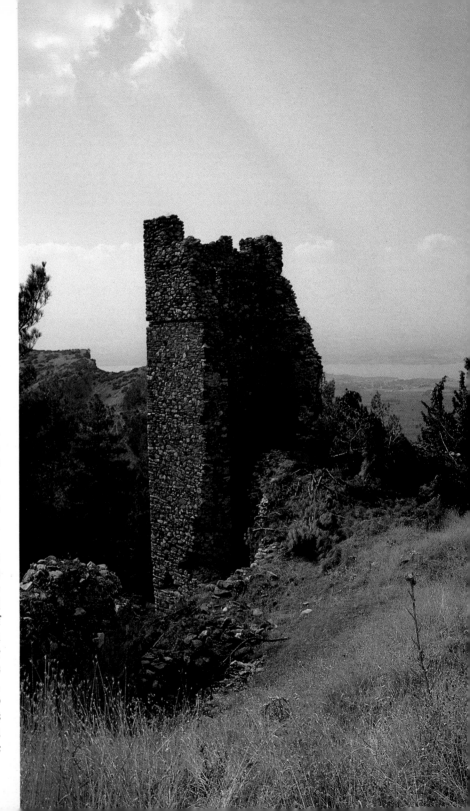

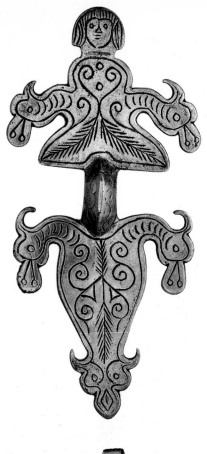

41 (*Far left*) Cast-silver brooch, one of a pair from a hoard found at Martynovka in the Ukraine, USSR, 6th–7th century. The incised decoration represents foliage and ears of grain, as well as human and animal heads, and the hoard, which includes Byzantine silver, probably belonged to a local Slav leader.

42 (*Left*) Avar ear-ring, made of gold no doubt extracted by force from Byzantium. From Hungary or the Ukraine, USSR, 6th–7th century.

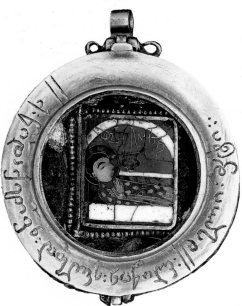

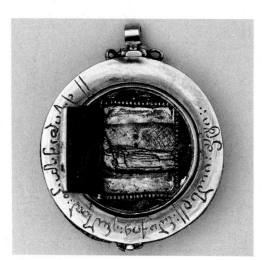

43 Gold and cloisonné pendant, probably made in Thessalonica *c.* 1200. The front, shown closed and open, has two images of St Demetrius in his shrine. The inscription in Georgian refers to its use as a reliquary of the True Cross by a 17th-century queen of Georgia, St Kethevan. The back has a cloisonné enamel bust of St George.

policies, which has allowed historians to invent vastly different versions of the latter. Heraclius came from a military background in the reconquered province of North Africa and seized the throne from the discredited Phocas in 610. In the Balkans the Arabs and Slavs were being joined by yet more barbarians, the Serbs and Croats, whom Heraclius managed to divert west and north on to the Dalmatian coast. There was, however, no chance of reversing the barbarian settlement of the Balkans, whereas Khusro II had not yet had chance to consolidate his gains in Asia Minor and Egypt. In 622 Heraclius launched his campaign against Persia.

Now Byzantium faced her greatest threat: with her army occupied in the east, her enemies combined against her. An alliance of Persians, Avars and Slavs led in 626 to the siege of Constantinople, the first of many throughout the history of Byzantium in which the fate of the city seemed to symbolise the fate of the whole empire. All possible resources were mobilised, church silver was melted down for cash, and the Patriarch Sergius took command in the emperor's absence. In practice the inability of both Persians and Avars to challenge Byzantium's control of the sea proved decisive, but the danger was so great that the citizens saw their salvation in divine terms. The Virgin Mary was the prime supernatural defender of Constantinople, and the city housed many of her relics, such as a fragment of her robe. Now icons of the Virgin were taken round the walls and prominently displayed on the gates in the face of the enemy. After the siege was raised Sergius composed a victorious hymn to the Virgin; it became the prologue to the Akathistos Hymn, which is sung during Lent and so has a permanent place in the Orthodox liturgy.

Heraclius, meanwhile, had succeeded in taking the Persians by surprise by sailing along the Black Sea and attacking from the north through the mountains of Armenia. In six years of warfare he recovered Byzantium's losses in Asia Minor and Syria and invaded deep into Mesopotamia, sacking Khusro's palace at Dastagird. In 627 he won a decisive battle against the Persians at Nineveh; an internal revolt broke out and Khusro II was murdered. The Sassanian Empire collapsed and in 630 Heraclius entered Jerusalem in triumph to restore the True Cross.

The Cross had long been the symbol on the reverse of Byzantine coinage, but Heraclius' achievements brought it to new iconographical pre-eminence. The theme was further stressed by an Anglo-Saxon jeweller when he set a coin of Heraclius, dating from about 620, into a cross-shaped piece of gold and garnet jewellery. To wear a Byzantine coin as a pendant was obviously a high status symbol in the barbarian kingdoms of western Europe. On the obverse of the coin Heraclius is shown with his son Constantine, stressing as the first Constantine had done the hope that he was founding a new dynastic line. But even before his heirs could succeed Heraclius had seen his achievements wither in the face of a new and even more devastating attack.

44 Anglo-Saxon gold cross from Wilton, Norfolk, c.620. The Byzantine coin is set upside-down into the pendant, but the quality of the garnet inlay suggests the cross was made in the same workshop as the jewellery found in the royal ship burial at Sutton Hoo, Suffolk.

40

inside front cover

44

35

4 Islam and Iconoclasm

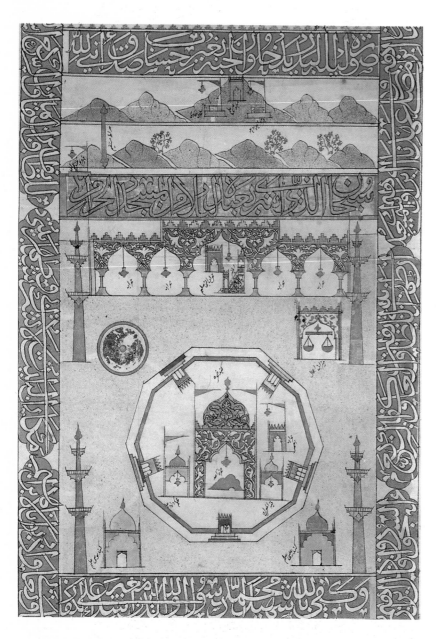

45 Dome of the Rock and Aksa Mosque, Jerusalem, from a pilgrimage scroll of 1544/45 (Istanbul, Topkapı Saray Müzesi). The Dome of the Rock, built on the site of Muhammed's 'Night Journey' to Heaven, was decorated in the late 7th century by Byzantine mosaicists.

The timing of Heraclius' campaign against Persia is one of Byzantine history's most bitter ironies: 622, the year in which he embarked on his life or death struggle, was also the year in which the prophet Muhammed made his flight, the Hijra, from Mecca to Medina, which was adopted as the year one of the Islamic calendar. Muhammed was a merchant from an influential Meccan tribe, married to an older but wealthy wife, who began to see visions and, hearing the command 'Recite', uttered the verses which were written down as the Koran. Rejected at first by his own tribe, the Quraysh, and by the successful trading community of Mecca, it was in Medina that he found sufficient social discontent to fuel his incipient movement and to win his way back to Mecca by force. Force was thus present in Islam from an early stage, and one way to unite the disparate nomadic and commercial strands of Arab society was to turn this force outward. The wars of conquest started in 636, within a few years of Muhammed's death.

Arabia was outside both the Byzantine and Persian empires, but both powers had tried to enrol at least the northern Arabs within their spheres of influence. Justinian had been in diplomatic contact with the Ghassanids, and Khusro II made war on the Lakhmid Arabs when they failed to support him in his civil wars. This last was an unwise move, since the removal of the Lakhmids as a buffer-state opened Persia to attacks from Arabia. The victory of an Arab alliance over the Persians as early as 604 was an early pre-Islamic foretaste of what was to follow.

Persia, in total disarray after Heraclius' campaigns, could pose no effective resistance to the main Arab attacks in the 630s. By the early 640s the conquest of all the Persian territories as far as the Caucasus was complete; the Sassanian dynasty ended in 651 with the murder of the last king. Sassanian structures and attitudes however had a continuing influence under Islamic rule, es-

pecially after 750, when the seat of Islamic government, the Caliphate, was moved to Baghdad, in the heart of what had been the Persian Empire. A silver dish which dates from the late seventh or early eighth century shows something of the survival of the Sassanian style (cf. 33): a prince reclines in a garden, surrounded by all the requirements of civilised life – musicians, quantities of drink, and a woman kneeling before him. The clothes and the woman's pose are oriental, but the atmosphere is still redolent of the long-gone Sassanian court.

Byzantium, the victor in the Sassanian wars, fared little better than Persia in the face of the Arab assault. The first attack in 636 was directed against Palestine and Syria, and Jerusalem fell for the second time in 638: it was to remain in Islamic hands until the First Crusade at the end of the eleventh century. In 640 the Arabs turned west into Egypt, and advanced relentlessly through North Africa, which was thus permanently lost to the Byzantines a century after Justinian's reconquest. Most threateningly, the Arabs developed their own fleet, and so were able to wage war at sea. They raided the eastern Mediterranean islands and in 674 launched their sea-borne siege of Constantinople.

A cache of silver which emerged from Cyprus at the turn of the nineteenth century is

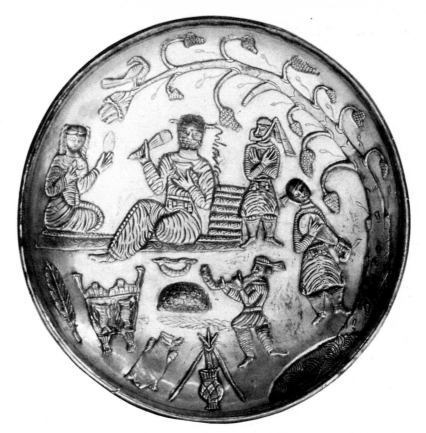

46 (*Above*) Silver dish, carved in relief with some applied relief decoration. Probably made in north Iran after the Islamic invasions, but its date is uncertain. Compare a similar scene on the border of 33.

47 (*Below*) Silver dish from the First Cyprus Treasure, 578–582. A similar example in the Second Cyprus Treasure supports the suggestion that the two treasures may originally have been one.

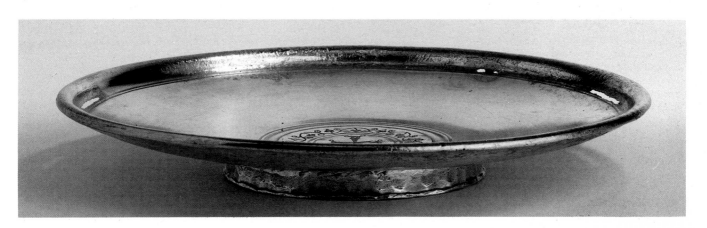

an eloquent witness to this last act in the drama which saw the end of the classical world. The 'First Cyprus Treasure', also known as the Lambousa Treasure, (now in the British Museum) consists of silver objects of a largely religious character. The 'Second Cyprus Treasure' emerged a few years later in two separate finds, of gold objects and silver plates, both of a largely secular nature. It is now divided between the Metropolitan Museum, New York, and the Cyprus Museum in Nicosia. Despite their different characters it is possible that the finds originally formed one treasure belonging to a single individual.

Lambousa, classical Lapethos, was a Byzantine town on the north coast of Cyprus, and the richness of the objects shows that it must have been in close touch with the capital. The silver can be closely dated by its stamps, and some objects date from the last decades of the sixth century. A circular dish with a central cross may be a very early example of a paten for consecrated bread, and a censer, which dates to the reign of Phocas, is a fine and rare example in precious metal of this type of liturgical vessel.

The silver plates in the Second Cyprus Treasure bear control stamps of Heraclius, and may be associated with the emperor in a more personal way. They show nine scenes from the life of David, culminating in his victory over Goliath, which may well be a direct reference to Heraclius' single combat in 627 against the commander of the Persian army. The David theme was to become a popular one in Byzantine art; it emerges again in manuscript illuminations of the tenth century, and its use reflects the perception Byzantium developed of itself during these crisis-ridden centuries: beset by overwhelming military odds, but always supported by its consciousness of divine providence.

The evidence which links the burial of at least the First Cyprus Treasure to the Arab invasions is provided by a silver bowl with control stamps of the first half (641–51) of the reign of Heraclius' grandson, the emperor Constans II (641–68). This is one of the finest pieces in the Cyprus Treasure, but it is also the latest datable piece of Byzantine silver to have survived. The practice of stamping silver, and presumably therefore the bureaucracy necessary to impose its control, came to an end in this reign. Lambousa was completely destroyed by Arab raids in 653/4 and most other coastal cities of Cyprus suffered the same fate at around this time. By a treaty with the Arabs in 688 the island passed out of Byzantine control.

Thus, little more than a century after the death of Justinian, Byzantium had lost not only the reconquered provinces – North Africa to the Arabs, Spain to the Visigoths, most of Italy to the Lombards – but a large proportion of its core territories as well – Egypt, Palestine and Syria to the Arabs, Greece and the Balkans to the Slavs. The Avars faded from the picture in the mid-seventh century, but their place was taken by the Bulgars, people of nomadic origin but eager to settle in the lands of the Roman Empire. In 680 they crossed the

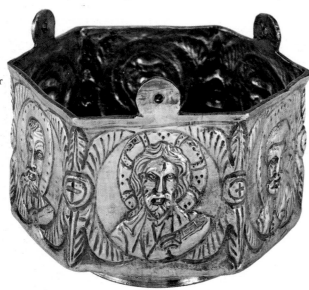

Danube and set up an independent kingdom in what is now Bulgaria. Amid all Byzantium's problems, the creation of a nation state on imperial territory so close to Constantinople was particularly hard to tolerate. It was a direct blow to Byzantium's universal self-image, and the empire waged war against Bulgaria almost unceasingly for 350 years. Against the Arabs, too, resistance continued. A siege of Constantinople in 674 turned into a five-year blockade, but the city held out, as it did against a second siege in 717. The Arab advance by land was eventually halted in Asia Minor; they invaded and raided constantly, but could not gain a secure foothold on the Anatolian plateau. After the Caliphate was moved from Damascus to Baghdad the force of Arab attacks waned, but they were still capable of launching serious raids against Byzantine territories by land or sea. It was not until the tenth century that Byzantium managed to turn a defensive war into an aggressive one, and for three hundred years they fought on two fronts with no certainty as to the outcome.

Wars on this scale placed a great stress on the institutions of Byzantine society. The emperor's position was far from secure: in 695 Justinian II was toppled from his throne in a protest against excessive taxation led by the Blues, although he managed to regain power in 705 with the help of the Khazars, Turkic nomads based at the eastern end of the Black Sea. Longer-term changes concerned the civil aristocracy, which was defined by office rather than inheritance, and which had supplied the imperial and provincial administration of the empire. Military appointments were now the key to advancement, and a new system of provincial government was developed, dividing the territories first of Asia Minor and then, as they were recovered, of the Balkans, into military units or themes; soldiers were then given lands in these areas to provide a standing army. These centuries saw massive exchanges of population, as different ethnic

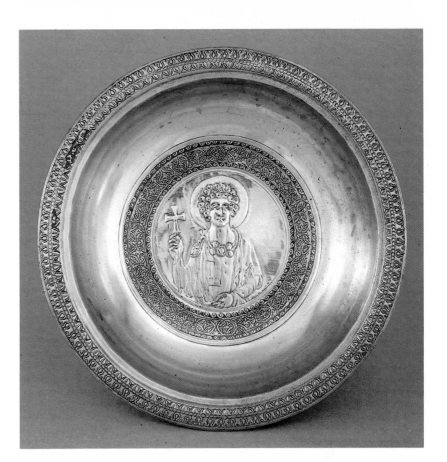

51 This ivory panel showing the Nativity and Adoration of the Magi comes from a monastery in Thessaly, Greece, where it was framed for use as an icon; it was probably originally made in Syria or Egypt in the first half of the 6th century. Narrative details in the lower scenes include the midwife mentioned in the Apocryphal Gospels whose hand was paralysed when she cast doubt on the Virgin Birth.

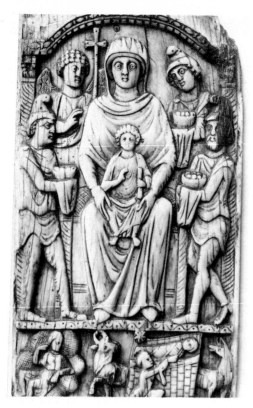

groups were shifted around to protect the frontiers in accordance with changing military demands.

With such strain on the social fabric, it is not surprising that a society like Byzantium, which defined itself in religious terms, should have undergone a religious crisis. Historians have struggled to find social, economic and political causes to explain the phenomenon of Iconoclasm, but are currently inclined to accept the Byzantines' own evaluation: a crisis of belief in the practice of directing the worship of God through the veneration of pictorial representations of Christ, the Virgin and the saints. The decision to ban such images was taken by the emperor Leo III (717–41), and was the official policy of the empire from 726 to 780 and again from 813 to 843. A century and a half of artistic destruction has left a gaping hole in Byzantine art history, while the

ultimate victory of the pro-icon party, the Iconodules, has given an inevitable bias to the surviving literary evidence, so that it is even more difficult to reconstruct the original arguments.

An icon is simply an image, in any medium, whether a portable one on wood, ivory, silver or textile, or a more structural one in wall-painting or mosaic. Rare examples in all of these media survive from before Iconoclasm, including a remarkable collection of wooden icons painted in encaustic from St Catherine's Monastery in Sinai. A sixth-century ivory of the Virgin and Child shows how such an object was created as a focus of veneration. The narrative interest here is confined to the subsidiary scene: the central image with its direct gaze leads the worshipper in to a consciousness of the holy presence. The icon itself is not an object of worship, but a vehicle through which worship can be directed and conveyed; hence it is effective not by being in any sense a likeness of the person but by representing the person's essence. This is why the images of the saints as shown on icons remain constant, allowing for stylistic differences, over the centuries; why the St Peter on the Cyprus silver censer is recognisably the same saint as on a fourteenth-century painted icon. There is no place here for artistic license: the truth of a person does not alter with time. This use of material substances to convey divine qualities is crucial to understanding Byzantine attitudes.

The use of icons seems to have developed in the fifth century and become more widespread in the sixth, and reflects a period characterised both by mass conversion and enthusiasm for theological speculation. In parallel to this, however, a tradition which avoided the use of icons continued which had firm roots in Jewish art, with its ban on graven images. An important example of this is the decoration of the Ayia Sophia in Constantinople. Justinian's church had no fresco or mosaic icons on its

inside front cover

walls: all the figural decoration dates from after Iconoclasm. Contemporaries commented on the way the eye was allowed to roam freely over the marble revetments and patterned mosaics so as to increase the impact of the building's monumental volume. This was probably a primarily aesthetic decision, but it shows that even in the sixth century icons were not an essential structural element in the interior furnishings of the greatest church in the Byzantine world.

There were plenty of signs, though, by the seventh century that attitudes for or against icons were hardening. One indication was the attack on what might be called the middle way. The practice of referring to divine figures by the symbols associated with them had flourished in the early church and was still widely used; the Justinianic churches in Ravenna, for instance, used the lamb to refer to Christ (San Vitale), and the Cross and three sheep to refer to Christ and the apostles at the Transfiguration (Sant'Apollinare in Classe). By the end of the seventh century the practice of reference by symbolism came under direct attack, in the canons of the Quinisext Council (between the Fifth and Sixth oecumenical Councils) held in 692. To refer to Christ indirectly no longer conveyed his full essence; this could only be expressed by his image in human form.

Popular devotion to icons was clearly on the increase, though it is hard to say whether, as the Iconoclasts claimed, this over-enthusiasm was leading to misuse and the line between veneration and worship of the material object was being crossed. The fervour was likely to produce a backlash, and the Iconoclasts had one striking fact in their favour; not only were the icons failing to protect Byzantium, but her principal enemy, the Arabs, ruthlessly banned all figural images and were proving victorious on all fronts. The contrast could hardly be starker, and was certainly not lost on Leo III, the first member of the new Isaurian dynasty

from northern Syria who had himself come to power through his participation in the Arab wars. In 726 he took the symbolic step of removing the image of Christ over the Chalke Gate of the Great Palace in Constantinople, and in 730 called a Church Council to order the destruction of all icons.

As well as removing existing images, Iconoclasm obviously precluded the creation of any new ones. This raised a problem for church decoration which was also felt by church architects. Few new churches were built during this period: one such may be the Ayia Sophia at Thessalonica, although the exact date of its construction is not known. This church has long been recognised as an important point of transition between the domed basilica of the sixth century and the smaller central-plan church of the middle Byzantine period. The exterior still reveals little of the internal structure, but the core of the church is cross-shaped, with a large dome supported on barrel-vaults. The east end is divided up into the tripartite sanctuary area, which was to become a standard feature. The sanctuary has one of the best preserved examples of Iconoclast decoration: the barrel-vault mosaic, with its huge cross, has donors' inscriptions of

52 A unique example in ceramics of symbols referring to divine figures: this fragment of Egyptian Red Slip pottery bears an elaborate jewelled cross flanked by two lambs. It can be dated by careful comparative work to the second quarter of the 6th century, which places it at the very end of the production of mass-produced, fine-quality pottery: this was another casualty of the collapse of the economic base of Byzantium.

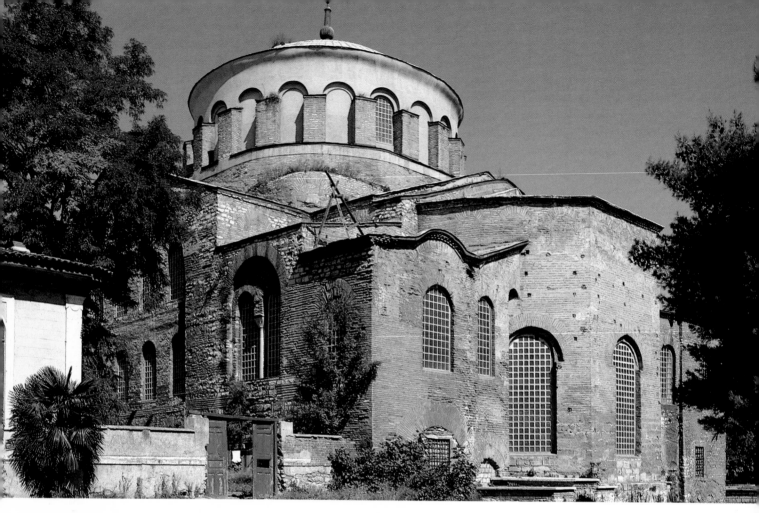

Constantine VI and of his mother, the empress Irene, while behind the Virgin and Child mosaic in the apse, which presumably dates from after 843, the traces of another large cross can be made out. Ironically, Constantine and Irene were responsible for restoring images in 780, and for calling the Seventh Oecumenical Council of Nicaea in 787, which produced a theological defence of icons that was to lay the basis for subsequent Orthodox practice but this does not seem to have affected their choice of decoration in the Ayia Sophia, Thessalonica.

The course of Iconoclasm was closely linked with the military and political fortunes of

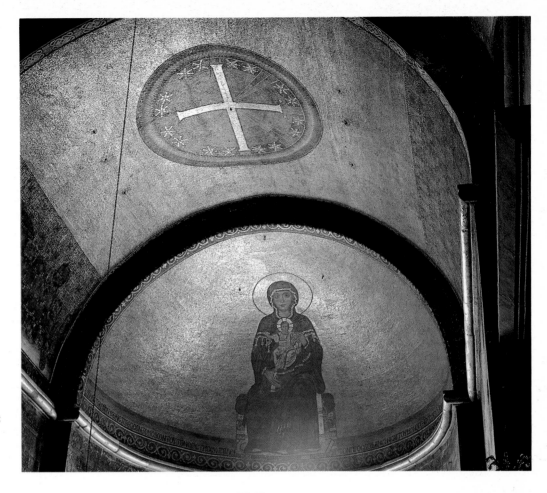

Byzantium. Constantine V continued the policy of his father, Leo III, while he too energetically pursued the war against the Arabs. The restoration of images in 780 occurred at a time of greater military security, as Arab attacks waned, but of weaker imperial authority, with the empress Irene ruling as regent (780–97) on behalf of her son, Constantine VI. The second outbreak of Iconoclasm followed severe reverses on the other war front, against the Bulgars in the Balkans. In 811 the emperor Nicephorus I was defeated and killed by the Bulgar Khan Krum; Byzantium saw her ultimate humiliation when the emperor's skull was turned into a drinking cup. His successor, Leo V, reimposed Iconoclasm, but in 843 it was finally abandoned during another period of regency. The implication is that Iconoclasm could only be imposed by a strong emperor at a time of national crisis; it never enjoyed any widespread popularity.

In 867 the mosaic of the Virgin and Child, which is still to be seen in the apse of the Ayia Sophia, Constantinople, was consecrated amid great celebrations; it marked the ultimate resolution of the Iconoclast controversy. The same years saw the inauguration of a new dynasty in Byzantium which was to usher in perhaps the most prosperous and productive period in its thousand-year history.

5 The recovery of nerve

In 867 a new emperor succeeded to supreme power, Basil I, who was to found one of the longest surviving dynasties in Byzantine history. At last there seemed to be a lightening of the crisis-ridden atmosphere which had hung over Byzantium for so long. An intellectual revival seems to have begun under the last of the Iconoclast emperors, Theophilus (829–42), and a decisive victory over the Arabs at Poson in 863 under his successor Michael III (842–67) marked the point when Byzantium was at last able to take the military offensive. The arrival of the Macedonian dynasty – so called because Basil I came from the Macedonian theme which was actually in Thrace – was just one of the changes which was to launch Byzantium into a second golden age.

Basil I did not seem the most promising figure to preside over a cultural revival. He was from a peasant family and had come to Constantinople as a groom; his first language was Armenian rather than Greek, and throughout his life he could neither read nor write. Nevertheless, some of the finest Byzantine manuscripts in existence were produced for him in the imperial scriptoria, his son, Leo VI, was known as 'the Wise' because of his legal reforms, and his grandson, Constantine

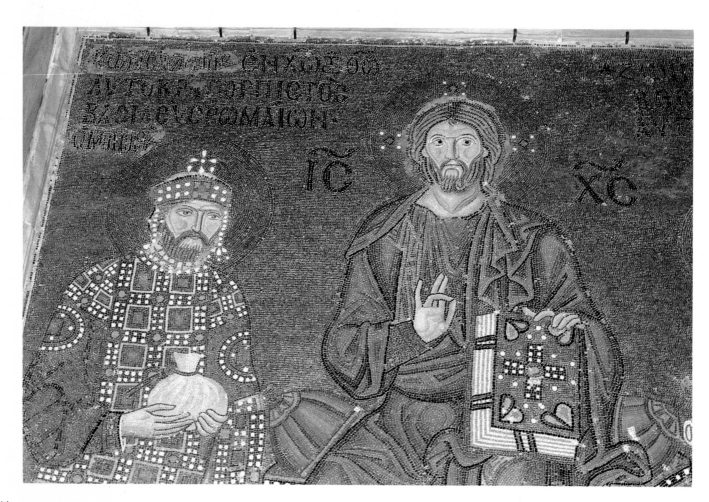

VII Porphyrogenitus, was the most scholarly emperor ever to sit on the Byzantine throne. Through marriages with a succession of promising generals like Romanus I Lecapenus, Nicephorus II Phocas and John I Tzimisces, the Macedonians managed both to provide a run of strong emperors and to retain the dynasty's grip on the throne. A visual witness to this process is provided by the mosaic in the gallery of the Ayia Sophia, which features the last of the dynasty, Zoe. The accompanying portrait of her first husband, Romanus III Argyrus, had to be altered to keep up with the empress' successive marriages, and now shows the face of her third husband, Constantine IX Monomachos.

The cultural revival anticipated the military successes, but it was also fuelled by them. For some two centuries Byzantium was able to reassert her military pre-eminence, though it was not through force that she was to make her most enduring impact on her neighbours. The conquests of Nicephorus Phocas, John Tzimisces and Basil II were ultimately to prove no more permanent than those of Justinian, but while they lasted, especially in the Balkans, the Byzantines were able to achieve a religious and cultural cohesion which guaranteed their influence over their western and northern neighours long after their moment of military supremacy had passed.

In 860, three years before Michael III's victory over the Arabs, two Byzantine missionaries from Thessalonica, Constantine, known as Cyril, and his brother Methodius, set out to convert the Khazars, Byzantium's old allies on the north-east side of the Black Sea. The mission failed, and Cyril and Methodius

57 The sombre figures of this ivory triptych are characteristic of the best products of the 10th-century artistic revival. The accompanying saints are Cyrus, George, Theodore Stratelates, Menas and Procopius (left), John of Syria, Eustachius, Clement of Ancyra, Stephen and Cyrion (right). On the back are saints Basil and Barbara (left), James the Persian and Thecla (right), and Joachim and Anne, the parents of the Virgin, in the centre of the crosses. The choice of Anne might imply a connection with the marriage of princess Anna to Vladimir of Kiev: state marriages were often commemorated on ivory.

moved on to the Central European kingdom of Great Moravia. In preparation for their work there they learned the Slav language, as yet only in oral form. Cyril devised an alphabet in which it could be written down; the result, Glagolithic, was thought too complicated, but a second version, known as Cyrillic, became the script of most of the Slav-speaking world.

The mission to Great Moravia also ultimately failed, and in 885 refugees from there, disciples of Cyril and Methodius, found their way to Bulgaria, where they embarked on an enthusiastic programme of translating texts and training clergy. The conversion of the Bulgarians had taken place some twenty years earlier. On the request of the Khan Boris, missionaries were sent from Rome and Constantinople. In 864 Boris accepted baptism from the Byzantines, taking the name of Michael; the emperor stood as godfather. It was probably intended on both sides as a political move: for the Byzantines it removed the embarrassment of a pagan empire on imperial soil, and it gave the Bulgar khan a position within the imperial system.

The conversion of the Bulgarians, however, did not ease their difficult relationship with Byzantium, and they strove to preserve their ecclesiastical independence by appointing their own patriarch. The military struggle between the two powers continued, while the imperial ambitions of Boris' son Simeon brought his army as far as the gates of Constantinople. Byzantium was the model to which Simeon aspired: his capital at Preslav was full of buildings which would not have disgraced the imperial city – his Round Church with its double tier of columns and central plan stands firmly in the main tradition of Roman architecture.

The peace treaty of 927 after Simeon's death was cemented by the marriage of Peter, his son and successor, to a Byzantine princess. The truce with the Bulgarians allowed Byzantium to revert to war on its eastern frontier, and by the mid-960s she had recaptured the cities of Tarsus, Aleppo and Antioch. For the first time since the seventh century the frontier was extended into Syria, and Crete and Cyprus were recaptured.

The mid-ninth century had brought Byzantium new enemies: the Rus, Vikings from Sweden who had planted settlements along the Russian rivers, arrived at Constantinople in 860. For these Vikings Miklegard – their name for Constantinople – was a city of wealth and fable; they came as traders and stayed as mercenaries to defend the emperor in the famous Varangian Guard. They showed a more aggressive intent, too, and with the advantage of their naval background were able to stage two sieges of the capital by sea; they also attacked by land through Bulgaria. The sea attacks were held off, largely by use of a Byzantine secret weapon: 'Greek fire' – some sort of liquid petroleum which could be thrown on to the enemies' ships and which exploded on impact, but whose constituents are not known even today. In 971 the Rus were decisively defeated by land at Silistria on the Danube.

The conversion of the Rus followed a similar course to that of the Bulgarians. In 988 Vladimir, prince of Kiev, co-operated with Basil II in a venture in the Crimea, in return for which he received in marriage Basil's sister Anna. As she was a princess of the imperial blood, Vladimir's conversion was a prior requirement. The prince was baptised in the waters of the Dnieper, and a huge delegation of bishops and priests embarked on the long task of the conversion of Russia. There Vladimir's conversion brought a rapid building programme: the principal church of Kiev owes its cross-domed plan to the Holy Apostles or Basil I's new palace church, but it is named after the Great Church, Ayia Sophia.

Ecclesiastical diplomacy on such a scale had brought Byzantium into direct conflict with the other ecclesiastical power-broker, Rome.

57

Of the original five patriarchates, three were under Arab control. The patriarchate of Constantinople had gained a *de facto* leadership through its close relationship with the emperor, but Rome was making its own bid for universal authority based on its foundation by Peter. The coronation of Charlemagne as Emperor in the West in 800 by the Pope gave Rome a separate source of imperial backing, and in the mid-ninth century Rome and Constantinople were fielding rival missionaries in Moravia and Bulgaria. The struggle came to an open quarrel when Photius, a professor from the university of Constantinople and the greatest scholar of his day, was suddenly elevated to the patriarchate. Rome seized on his unorthodox promotion to deny him recognition in 863 and Photius replied by an all-out attack on the practices of the Roman Church. The schism between the two Churches lasted till 879. The quarrel was not only political. There were disagreements over church discipline and, most seriously, over theology: it was Photius who defined the issue

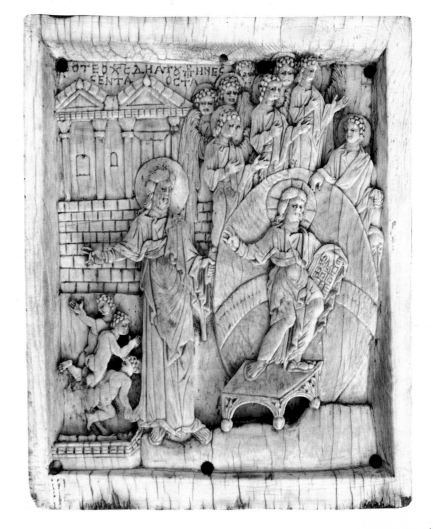

58 On this complicated ivory representing the vision of Ezekiel the inscription probably translates 'Then through the prophet Christ raised the bones'; the small curly-haired figures represent the great host of the house of Israel who were raised to life. The vision of Ezekiel was regarded as a foreshadowing of the Resurrection.

on which the ultimate schism was to occur, the addition by the western Church of the word *filioque*, 'from the Son', to the statement in the Creed that the Holy Spirit proceeds from the Father.

The Byzantines had a deep attachment to the concept of God existing in three persons and kept a keen sense of the separate character of each. A tenth-century ivory shows one way in which the character of the second person of the Trinity was given iconographical expression. The scene has been interpreted as the Anastasis, the Descent into Hell, but it is not a scene from the New Testament at all: the inscription refers to Ezekiel's vision in the valley of dry bones. The text of Ezekiel speaks of God raising the bones, but the figure shown here is that of Christ; the mandorla and the rainbow which supports Christ's footstool emphasise that He is shown out of time.

The vision of Ezekiel was a popular subject in the Macedonian period: it features, though in a more traditional iconography, in a copy of the Homilies of St Gregory Nazianzen which was specially executed for Basil I. Imperial patronage is the key to the tenth-century artistic revival. There was a demand for explicit imperial iconography, as is shown by the ivories celebrating imperial marriages and coronations, and by the mosaics in the Ayia Sophia showing past and present emperors being blessed by Christ and the Virgin. Emperors commissioned illustrated manuscripts, silks, gold and enamel reliquaries, many as diplomatic gifts for impressionable foreigners; Constantine VII was said to be himself a fine painter, and able to instruct any of his craftsmen, whether they were stonemasons, carpenters, goldsmiths, silversmiths or blacksmiths. These craftsmen, and all the workers who serviced the population of tenth-century Constantinople, lived under close state control and detailed regulations governed the production and sale of everything from silk to bread. The bureaucracy which ran the system was itself arranged in careful order of precedence, and at the pinnacle of the edifice the emperor moved around the city according to a pre-ordained schedule of imperial ceremonies, whose solemn order would act out the continuing ideal of universal and divine harmony.

Accounts of these ceremonies, like that written by Constantine VII himself, describe the backcloth against which they were held, the Great Palace Constantinople: the Porphyry Chamber in which the 'Porphyrogeniti', the imperial children, were born; the Hall of the Nineteen Couches, where representatives of the Blues and Greens ritually acclaimed the emperor; the Magnaura Palace whose mechanical throne set amid roaring golden lions and twittering golden birds so impressed the ambassador Liutprand of Cremona and through him inspired W.B. Yeats' vision of Byzantium. But one needs a poet's imagination to conjure up the Great Palace from its pitiful archaeological survivals: the battered façade along the harbour wall and a few fragments of mosaic floor. Later building on the site (the Blue Mosque occupies the top of the hill and the railway cuts through lower down) has prevented excavation on any scale and the finds hardly reflect the richness of the building. One piece which does, and which is said to have come from the Great Palace itself, is a gold and cloisonné enamel reliquary of the Virgin, flanked by St Basil, the founder of monasticism in the east, and St Gregory Thaumaturge, the Wonder-Worker. Enamel-working is one of the arts which reached its height in Byzantium during this period. The cloisonné technique was known in antiquity but apparently did not continue in use in Byzantium; it seems to have been re-introduced there in the ninth century under the influence of the Carolingian West.

Imperial patronage and influences from abroad all contributed to what historians commonly refer to as the Macedonian Renaissance, implying a deliberate revival of the

59 (*Above*) The front of this reliquary has been lost; given its shape it probably showed the Crucifixion and contained a piece of the True Cross. The surviving back dates from *c.*1000, and uses seven colours of cloisonné enamel.

60 (*Right, above*) Ivory panel of the Nativity and Annunciation to the Shepherds, 10th century.

61 (*Right, below*) Marble panel from Constantinople, 10th–11th century, probably part of an altar screen. The eagles, hares and serpent may have allegorical significance. Byzantine sculpture was less affected by the classical influence seen elsewhere: the interest of the artists was in abstract patterning rather than in naturalism, as can be seen here on the fur and feathers.

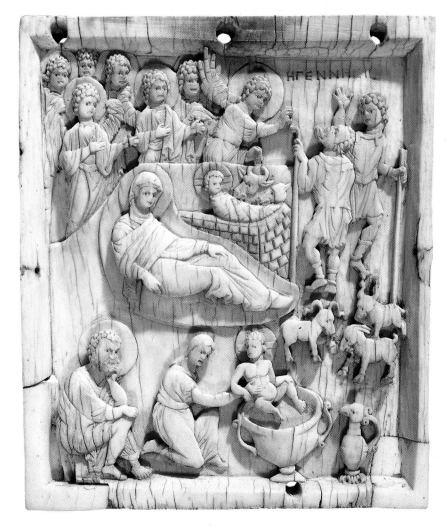

classical past. The main impetus to the outburst of scholarly activity at this time was the development of a new script, minuscule. This was quicker to write than the earlier uncial and took up less space: a campaign was thus soon underway to copy all existing manuscripts in the new script. Many classical manuscripts were saved, and Byzantine artists took up the classical models so enthusiastically that arguments still abound as to whether a particular manuscript is an original creation or a copy of a late antique work.

In the so-called minor arts, an ivory of the Nativity and Annunciation to the Shepherds is a fine example of the classical influence at work in the tenth century. The general layout of the scene represents a major development from the sixth-century ivory of the Nativity and Adoration of the Magi (p. 22). The theological meaning and narrative story are now combined. All the necessary figures are there, down to the ox and ass, but they are carefully arranged to frame the central figure of the Virgin herself, and the dramatic meaning of the scene is highlighted by placing the Nativity in a cave: this becomes a standard piece of Byzantine iconography after the tenth century. The arrangement of the figures is entirely geared to their religious function, but their treatment belongs to a very different world. Joseph sits in a corner cradling his head in his hand in the pose of a late antique philosopher, the midwife and the child she is bathing with water from an eagle-headed ewer are carved with naturalistic confidence.

Imperial patronage also extended to architecture: detailed descriptions survive, for instance, of Basil I's 'New Church' in the Great Palace, so that the influence of its five-domed plan can be followed through later buildings. Generally tenth-century churches had to meet a different need from their pre-Iconoclastic predecessors. Congregations were smaller, and money scarcer; indeed, many of the new churches were in monasteries, where much of

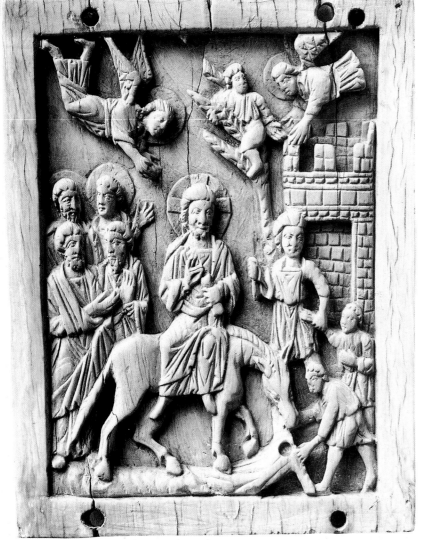

62 Christ's Entry into Jerusalem, one of the twelve 'Major Feasts' of the Church, shown here on an 11th-century ivory.

the empire's wealth became concentrated. So the churches shrank, and the standard plan became the 'cross-in-square' – a Greek equal-armed cross with four barrel-vaults and a central dome, and with the corners enclosed to form a square structure. This concentrated clerical activity at the eastern end, which was now divided into three parts, the prothesis to the left where the clergy made their preparations, the diakonikon to the right where the offerings were received, and the central sanctuary. The east end had been marked off by a low screen made up of marble panels; this 61 gradually developed into a closed barrier which hid the celebration of the eucharist from the congregation.

As the architecture of Byzantine churches became standardised, so did their scheme of decoration. Splendid mosaic cycles survive from churches of the Macedonian period, especially in Greece, which had been newly recovered by Byzantine armies. Smaller churches meant less surface area for mosaics or wall-paintings, so preference was given to the twelve 'major feasts' of the church, taken 62 from the Life of Christ and the Virgin. The iconography of these scenes also became standardised. Their position within the church could vary up to a point, but some combinations of image and architecture were especially favoured. The scenes which illustrate the Incarnation (Annunciation, Nativity, 63 Baptism and Transfiguration) are frequently grouped together, for example in the four pendentives supporting the dome at Daphni, outside Athens, which dates from the end of the eleventh century. The ever-popular image of the Virgin and Child had already come to rest in the apse of the sanctuary, as has been seen in the Ayia Sophia at Constantinople and the church of the same name at Thessalonica, while the vast scene of the Dormition of the Virgin, which expressed the Byzantine belief that the Virgin did not die, but fell asleep and was then taken up by Christ into heaven, spread itself across the flat expanse of the west wall. The keystone of the whole scheme is placed appropriately in the dome, from where Christ Pantocrator, Ruler of All, looks down, his left hand holding the Gospels and his right hand raised in blessing. The grim-faced Christ at Daphni, however, looks down more in judgment than blessing, and already in more temporal ways Byzantium was being judged and found wanting.

63 Icon showing the four 'Incarnation' scenes, the Annunciation, Nativity, Baptism and Transfiguration. It was found in Egypt, at a monastery near the Natron Lakes, but was probably painted in Thessalonica, *c.*1310/20: its style has been compared to that of frescos in the Church of St Nicholas Orphanos.

6 The revenge of the West

Byzantium's material fortunes changed many times over her thousand-year history, but none of these changes is more dramatic than the collapse which occurred within fifty years of the death of Basil II in 1025. Her cultural achievements continued unabated: the church of Daphni, for example (see p. 50), was not built until the end of the eleventh century, but the empire now suffered a series of political, military and economic disasters which can seem to have no connection with the triumphs of the earlier Macedonian period. In fact, of course, a host of underlying problems were already simmering beneath the surface, and it needed only another round of external pressures to bring them to the boil.

The Macedonian emperors had been great law-makers, and in a series of edicts had struggled in vain to protect the 'poor' against the 'powerful', the peasant soldier with his smallholding against the aristocratic families who were amassing land in the newly recovered provinces. The 'powerful' were further strengthened by receiving grants of state land to administer, which soon became hereditary. These families were not necessarily negative influences – several of them were to serve Byzantium well as imperial dynasties – but their existence inevitably weakened the empire's direct control over its land and its people.

The aggressive military policies of the emperors Nicephorus II Phocas (963–9), John Tzimisces (969–76) and Basil II (976–1025) had successfully pushed back the frontiers of the empire. In 1018, the last outpost of Bulgarian power in the Balkans was destroyed by Basil II, who earned the nickname Bulgaroctonos, Bulgar-Slayer, from the methods he adopted in his campaigns: after the final battle he blinded all his prisoners, leaving only one in every hundred to guide them back to Bulgaria. But the empire was overstretched, as it had been by the conquests of Justinian and Heraclius. Once again the ideal of universal empire had been asserted, only to result in war-torn, conquered territories which promptly succumbed to the next invader. This time it was the last of Basil's conquests that was the first to be lost: Armenia. In 1071 Byzantine forces were defeated at the Battle of Manzikert, north of Lake

64

64 Sandstone cross-slab or *khatchkar*, from a cemetery in the Levan region of Armenia. Commemorative *khatchkarer* occupy a special place in the history of Armenian art and religion. This one dates from 1225: the Armenians held on to their customs and their church under Seljuk rule.

Van, and the emperor Romanus IV Diogenes was taken prisoner.

The new victors were the Seljuks, who first appeared as chiefs of a confederation of Islamicised Turkish tribes. The main direction of their attacks was against the Arab Caliphate in Baghdad, whose authority over its original territories had eroded and become fragmented. In 1055 the Caliph gave the Seljuk leader the title of Sultan, his secular representative, with full charge of temporal affairs. The Seljuks proceeded to establish an empire which covered the whole of the Caliphate from the Oxus to Syria, although they too found it hard to hold: within a few generations their power had crumbled. On Byzantine territory, however, the Sultanate of 'Rum', established within a decade of Manzikert, became the most successful of the Seljuk states.

Romanus IV was not allowed to survive his defeat. A proven general, he had only been made emperor in the face of the Seljuk threat after a long line of civilian rulers who had allowed military resources to be dangerously depleted and who had begun the debasement of the gold coinage. On his return to Byzantium Romanus' eyes were put out and another civilian emperor, Michael VII, was appointed. No further resistance was offered to the Seljuks.

The pressure on Byzantium came not only from the Turks. Ever since her foundation Byzantium had acted as a magnet for the west. But while Byzantium was in a much reduced state by the end of the eleventh century, new medieval kingdoms emerging in western Europe were becoming increasingly formidable. Normans of Viking descent had begun to settle in Italy and Sicily in the early eleventh century. In 1059 Robert Guiscard was recognised as duke of Apulia and in 1071, the year of the Battle of Manzikert, he seized Bari, the last Byzantine foothold in Italy. The Normans acknowledged the cultural sway of Byzantium: the great churches they built in the next

century at Palermo and Monreale in the kingdom of Sicily were decorated with Byzantine-style mosaics by Greek artists, and the same influence can be seen in a group of ivories which are thought to have been produced in southern Italy, perhaps at Salerno, in the eleventh century. They are known as 'oliphants', a shape long popular in the Germanic world, but in this case covered with decoration derived from Byzantium and the east. However, Byzantium's cultural pre-eminence did not protect her from the Normans' acquisitiveness: in 1081 Robert Guiscard seized Dyrrachium on the Greek mainland and advanced through Macedonia

65 Syria was part of the Seljuk empire in the 11th and 12th centuries, though it later fragmented into smaller states. This bowl in the sgraffiato technique from Aleppo, Syria, c.1200, shows a mounted bowman, and is painted in a pale yellowish glaze with green and aubergine staining.

66, 67 Two 11th-century oliphants which came to the British Museum from private collections: **66**, the Clephane horn (*below*), has scenes which invoke the Hippodrome in Constantinople; **67**, the slightly later Borradaile horn (*right*), has a variety of animal motifs.

and Thessaly. These were not casual raids – he was aiming at Constantinople itself.

Byzantium turned for help to Venice, the merchant republic which stood then just at the threshold of her glorious career. Venice was even more in thrall to Byzantine culture. 68 The great church of San Marco, originally built as early as 830, was rebuilt between 1063 and 1073, though its decoration took many centuries to complete. It is closely based on the cross-shaped, five-domed plan of the Holy Apostles in Constantinople, and today is a vivid evocation of what the great churches of Constantinople must have looked like. Once again, Venice's enthusiasm for Byzantine culture did not prevent her from exacting heavy terms for her help. She retook Dyrrachium – Byzantium's fleet was in an even worse state than her army – and received in return exemption from customs dues on her trade throughout the empire and grants of land for quays and warehouses in Constantinople. It was a severe breach in the Byzantine economy and one through which other Italian cities, such as Pisa and Genoa, were to follow.

The emperor who faced these new dangers was Alexius I Comnenos (1081–1118), the subject of the best-known Byzantine biography, the *Alexiad,* written by his daughter Anna. His family belonged to the military aristocracy, but he married into the civilian family of the Duci and tried to end the factional quarrels which had beset the empire. The diplomatic skills with which he had played off Venice against the Normans he put to repeated use against the Seljuks in Asia Minor and the Pechenegs, nomadic steppe peoples to the north; the latter were completely wiped out by his adroit manipulation of another nomadic group, the Cumans. Meanwhile, he exacted military obligations from the hereditary holders of state land grants, welding them with his mercenary troops to form a new professional army. The administration too was completely overhauled. Alexius and his lesser-

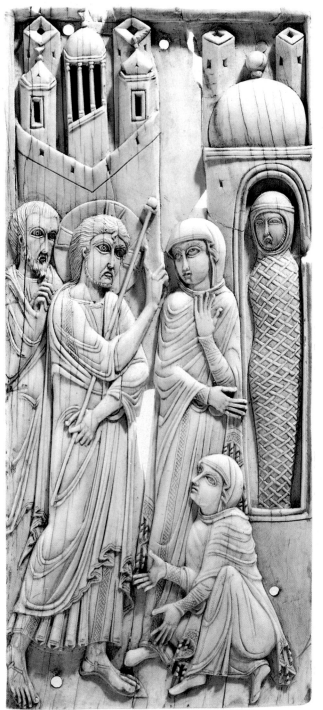

68 An enigmatic ivory which must belong to the Italo-Byzantine world of the 9th–10th century, made either in southern Italy or, more probably, in Venice. Its subject matter, the Raising of Lazarus, is a favourite Byzantine theme and one of the twelve 'Major Feasts', but it is treated here in a western manner.

known successors John II (1118–43) and Manuel I Comnenos (1143–80) did a great deal to restore Byzantium's internal and external authority. In 1097, however, an event occurred whose repercussions were to overthrow all their achievements: the First Crusade arrived in Byzantium.

From the fourth century pilgrims had made the journey to Palestine to visit the Holy Places associated with the life of Christ. The Tomb and the site of the Cruxifixion were both incorporated in Constantine I's Church of the Holy Sepulchre, which became the main goal of pilgrims and, later, of the Crusaders. Sites could be hallowed by the blood of more recent martyrs, and the persecutions of Diocletian had left no lack of candidates. Abu Mina, in the desert near Alexandria, was the burial place of St Menas, an Egyptian soldier martyred in 303. A century after his death a lavish complex of buildings arose there, financed by the eastern emperors and incorporating materials imported from Constantinople. The site of the burial was marked by a central-plan, four-apsed structure, which presumably housed a shrine, like the one represented on an ivory 69 *pyx* showing the martyrdom of the saint.

Nor was the blood of the martyrs a necessity for a successful pilgrimage. The phenomenon of the stylite saint was not uncommon in the early eastern church; one of the first and most famous was St Simeon in Syria: his pilgrim tokens show him on the pillar at Qal'at Si'man 70 where he stood for forty years. By isolating themselves from daily life in this way holy men like St Simeon gained great authority; they were much in demand to solve local problems and several operated on a national level.

These were just some of the pilgrimage centres which disappeared into Islamic control in the mid-seventh century. After the first force of the invasions was spent, arrangements were apparently made for pilgrimage to the Holy Places to continue. There was an unfortunate episode in 1009 when the fan-

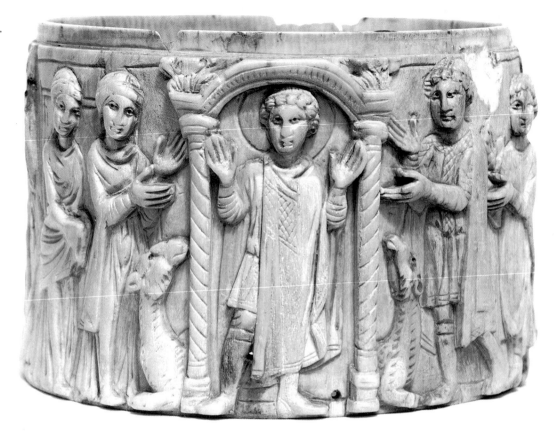

69 Ivory *pyx*, round box, probably made in Alexandria, Egypt, in the 6th century, showing on one side the martyrdom of St Menas and on the other pilgrims approaching his shrine in prayer. The saint is shown flanked by camels, recalling his occupation as a camel driver earlier in life, and the same image appears on numerous pottery pilgrim flasks.

atical Caliph Hakim tried to destroy all traces of the Holy Sepulchre, but Constantine IX Monomachos negotiated an agreement with his successors to restore the church and rebuild the rock-cut tomb in masonry. The real end to this relatively amicable arrangement came in 1077 with the arrival in Jerusalem of the Seljuk Turks.

Although Alexius had frequently asked the west for help in recapturing Byzantine territory from the Seljuks, he could hardly have foreseen the result: a Crusade to recover the Holy Places from the infidel, with leaders from most of the states of western Europe and backed by the moral authority of the Pope. In 1054 another schism had been declared between the eastern and western branches of the Church; this time it was not repaired, and as papal claims to universal authority grew stronger, the distrust between the east and west deepened. That the leaders of the First Crusade included Bohemund, the son of Robert Guiscard, confirmed Byzantium's danger. Faced with the Crusaders outside the walls of Constantinople – one of Anna Comnena's most vivid descriptions – Alexius made the best of the situation, forcing them to swear an oath of allegiance to him and to promise to restore all conquered territories to Byzantium.

The arrival of the Crusaders coincided with the collapse of the main Seljuk empire in the Middle East; Palestine was under the control of the Fatimids of Egypt; Syria had fragmented into city–states. This disunity gave the Crusaders their opening: they besieged and took Antioch in 1098 and in 1099 Jerusalem

itself. They did not, of course, hand over their conquests to Byzantium, but set up a series of principalities at Antioch and Edessa, and founded the Latin Kingdom of Jerusalem. Pilgrim tokens celebrating the recovery of the Holy Places, show the principal shrine of Christendom, the Church of the Holy Sepulchre, which was rebuilt. Its re-consecration in 1149 marked the fiftieth anniversary of the Crusader conquest.

By then, however, the Muslims were recovering from the disunity that had aided the Crusaders' victory. Zengi, ruler of Mosul, began the process of reuniting the Muslim cities of Syria and recapturing the Crusader ones. Edessa fell to him in 1144, Damascus to his son Nur-ad-Din in 1154, and Jerusalem to his even more famous successor Saladin in 1187. Saladin also brought to an end the Fatimid Caliphate in Egypt. The efforts of subsequent crusades, however, managed to prevent the total loss of the Latin Kingdom. Jerusalem itself was only recovered for a brief period by negotiations between 1229 and 1244, but the Latin Kingdom in a much reduced form survived until the fall of Acre in 1291.

Byzantium had not stood aloof from this process. Of the Crusader states, the Principality of Antioch established by Bohemund

was regarded as particularly hostile to Byzantine interests. In 1138, as part of his campaigns in Asia Minor and Syria, John II forced its ruler to swear allegiance to Byzantium, and in 1159 Manuel forced the king of Jerusalem similarly to acknowledge Byzantine sovereignty over the whole Latin East. The dream of once again re-establishing Byzantine universal empire, however, fared less well in the west. There were new players in the diplomatic game, such as Hungary, and the German Empire, which had its own imperial ambitions, while the national elements in the Balkans were breaking away into the independent states of Serbia and a revived Bulgaria. The Papacy, meanwhile, was actively extending its sphere of influence into Dalmatia and the Balkans. Once the personal authority of John II and Manuel had passed, catastrophes

71 A late example dating from the 12th–13th century of a lead *ampulla*, pilgrim flask, showing the Church of the Holy Sepulchre, Jerusalem, as it was rebuilt by the Crusaders; on the other side appear two soldier saints – Aetios and George – with kite-shaped shields.

70 (*Far left*) Pottery pilgrim tokens of St Simeon, showing the saint on his pillar, an angel and, below, the Baptism of Christ, 6th century. Other scenes from the life of Christ, such as the Annunciation or Entry into Jerusalem appear on similar pilgrim tokens from the Holy Land.

72 An English view of the Crusades: Richard Coeur de Lion anachronistically defeats Saladin on a panel assembled from inlaid mosaic tiles found at Chertsey Abbey, Surrey, c.1250.

followed thick and fast at the end of the twelfth century. The Seljuks in Asia Minor resumed the offensive at the Battle of Myriocephalum in 1176, Hungary and Serbia joined forces to attack the Balkan cities in 1183, and the Normans swept through Greece in 1185 to inflict a brutal sack on Thessalonica. There could be no effective internal response: the Byzantine state was barely functioning. Individual families took over whole provinces and the areas that remained were ground down by taxation. The last Comnene emperor Andronicus was torn to pieces in 1185 by the panic-stricken citizens of Constantinople, and the Angeli dynasty which followed was little more than a procession of usurpers.

The western powers gathered to deliver the decisive blow. In 1194 the German emperor Henry VI succeeded to the Norman kingdom of Sicily; his imperial ambitions now turned against Byzantium and he demanded grants of territory and a huge tribute. It could no longer be raised by taxation, and the tombs of the emperors in the Holy Apostles had to be stripped in order to pay. Henry VI died in 1197 before he could launch his invasion; appropriately he was buried at Palermo in funeral robes of Byzantine brocade. The attack was taken up by an unholy alliance of Pope Innocent III and Enrico Dandolo, the formidable Doge of Venice. The Pope summoned a Crusade and the Venetians provided the ships

– in exchange for the lion's share of the booty. The Byzantines thoughtfully provided an excuse, another Angelus pretender asked for western help on to the throne, and so the diversion of the Fourth Crusade from the Holy Land to Byzantium was decided. The Crusaders' fleet appeared off Constantinople in 1203, and forced its way into the Golden Horn. The city fell and the pretender was installed, but it was only a momentary respite. On 13 April 1204 the Crusaders entered Constantinople again, this time to sack it. They stripped the city and partitioned the empire. Byzantium had ceased to exist.

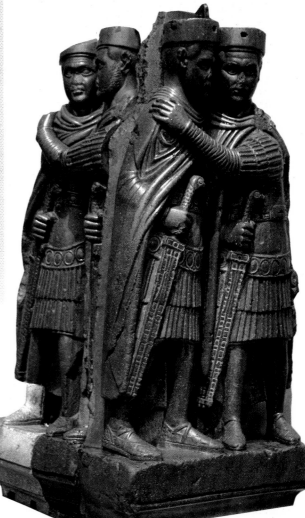

73 (*Above*) Fragment of the funeral robes of the German emperor Henry VI: crimson silk with a pattern of birds and animals woven in gold thread.

74 (*Right*) Porphyry statue of the four Tetrarchs of the 4th century (see p. 5), presumably brought as loot from Constantinople and incorporated in the south-west corner of San Marco, Venice.

7 The last flowering

The events of the Fourth Crusade left conquerors and victims alike reeling from the shock. It created a permanent legacy of bitterness and mistrust between eastern and western Christendom: the city which had been protected by the Virgin against all manner of pagan attack had been vigorously sacked by the forces of Christian Europe. One might be tempted to think of the Byzantine accounts of the sack as justifiably over-exaggerated, except that the accounts by Latin writers read just as horrifically. The city was stripped of its treasures. Venice especially took its promised share: it filled the treasury of San Marco with sardonyx bowls, gold and enamel book-covers, even the cherished icon of the Virgin which eleventh-century emperors had carried into battle. Byzantine sculpture was set into the walls of the church, and the four gilt horses which had stood in Constantinople – either in the Hippodrome or more likely in the central street – since the time of Constantine were ostentatiously displayed over the entrance.

Relics from the city's unrivalled collection were spread throughout western Europe. The crown of thorns from the Crucifixion had been one of the most prized relics in Constantinople: now it was given by the Latin ruler of the city to Louis IX of France and was eventually broken up among the French nobility. As the relics were spread more thinly, however, the attention lavished on them increased. Louis IX built the Sainte Chapelle in Paris as a suitable setting for the crown, and individual thorns were set into lavish reliquaries or pieces of jewellery. The great gold and enamel reliquary made as a setting for his thorn by Jean, duc de Berry, is a spectacular example. These fragmentary Byzantine relics inspired the finest achievements of contemporary western goldsmiths and enamellers.

The Byzantine Empire was partitioned among the victors with mathematical precision. There was a Latin emperor in Constantinople, Baldwin of Flanders: his territories

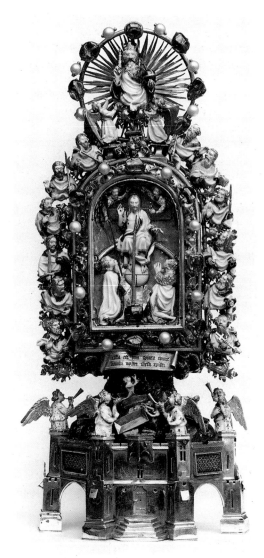

75 The centrepiece of the Waddesdon Bequest in the British Museum, made in Paris for Jean duc de Berry, *c.*1400–10. The Holy Thorn is set vertically in an uncut sapphire behind a rock-crystal window, amid a vivid scene of the Last Judgment.

included Thrace and north-west Asia Minor, but he did not have total control of his own capital, with three-eighths of Constantinople, including the Ayia Sophia, going to the Venetians. They were the principal victors in land as well as booty, receiving most of the islands and ports, including the Ionian islands, Euboea and Crete: the city-state of Venice had now acquired a colonial empire overseas. Cyprus had already been seized by Richard I Coeur-de-Lion at the time of the Third Crusade and given to Guy de Lusignan. Other Frankish lords divided up the rest of Greece under the loose sovereignty of Boniface of Monteferrat, the King of Thessalonica, so the pattern of feudal overlordship reflected that which had been imposed in the Holy Land a century earlier.

Crusader states now extended from Corfu to Acre. The scale of western settlement should not be exaggerated: the local population was not dispossessed, but the Crusader soldiers formed a feudal overlay, built large numbers of castles, and founded some civilian settlements. Byzantine influence has already been observed on objects produced in the west for the western market; now that market had expanded through most of the east Mediterranean. A Venetian cameo of the thirteenth century has a distinctly Byzantine subject: Daniel in the lions' den; like Jonah, it is an Old Testament theme taken over as a foreshadowing of the Resurrection and frequently used on early Christian objects. Such an item of jewellery, though, could only have a limited market, so the Venetians also made mass-produced medallions of coloured glass, which could be set as pendants. Many of these use eastern themes, or themes treated in an eastern manner, such as the Seven Sleepers of Ephesus, legendary victims of religious persecution, who emerged unharmed after two hundred years walled up in a cave. Other themes include popular eastern saints like St Nicholas or St Demetrius, or Byzantine iconographical types, like Christ Pantocrator or the Virgin Hodegetria, 'pointing the way' to the Child.

Of the eastern saints taken up by the west, St George was destined for a particularly successful career. On one brilliantly coloured icon the identification is made certain by the saint's name emblazoned in Greek red letters on the silvered background. He lacks a dragon, but the scene represented is far more specifically associated with St George, one furthermore known only in Greek sources, and which did not spread into western iconography. However, the emphasis on the swing and movement of horse and rider is a western style, and the bulging and rolling eyes of the figures are found in works in other media – manuscript illumination and wall-painting – associated with western artists working in the east, and on a small group of icons from Sinai which are now dated to the Crusader period. The implication, then, is that the icon was painted in the mid-thirteenth century in a Crusader state, perhaps even at Lydda in the Holy Land, which was the main pilgrimage centre for the cult of St George, but that the artist was a westerner, working for a western patron. The opposite interpretation, though, could also be offered, that it was painted by a Byzantine artist influenced by contact with the west. One other striking feature of the icon, its use of silvered gesso as a background, further illustrates the point: the Byzantines did cover some of their icons in silver revetment, and gesso relief ornament is a western technique, so is presumably imitating the silver, but this use of it seems to occur earlier in the east than in the west. Part of the appeal of Crusader art must lie in identifying this problematic balance between the training and experiences which influenced both artist and patron. This icon is an important piece of evidence in disentangling these complex strands.

Although Byzantium had lost its capital and most of its empire to the Crusaders, it had not been completely obliterated by the Fourth

76, 77 Western artists copied Byzantine works of art for both the luxury and mass markets. The sardonyx cameo (76, *above*) probably originally mounted on a ring, is one of four known examples which are cut in three colours and show Daniel between lions; Venetian, early 13th century. Hundreds of moulded glass medallions like 77 (*below*), which shows the Seven Sleepers of Ephesus, were also copied from Byzantine carved gems. They could be set as pendants; this one is in an 18th-century mount; Venetian, early 13th century.

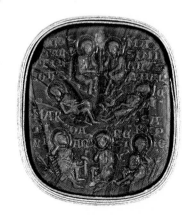

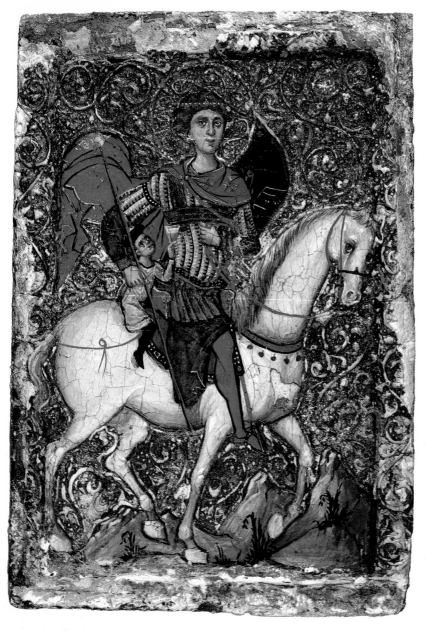

78 Icon of St George, mid-13th century. The story illustrated is that of a boy from the island of Mitylene, carried off during the Arab conquests to be a page to the Emir of Crete. His mother prayed to the saint for his recovery, and the boy found himself aloft over the Aegean, still clutching the glass of wine he had been in the act of pouring his master.

Crusade. Three 'governments-in-exile' emerged, each based on the power of a single family, the Comneni in Trebizond at the eastern end of the Black Sea, the Angeli at Epiros in north-west Greece, and the Lascarids in Nicaea in north-west Asia Minor. Trebizond was the most long-lasting of the three, not falling to the Turks until 1461, but was too distant to be involved in the mainstream of events. The other two became rivals for the inheritance; both Theodore I Lascaris in 1208 and Theodore Angelus in 1224, when he captured Thessalonica from its Latin ruler, were crowned and anointed emperor of the Romans. The outcome of the rivalry was determined by the intervention of an outside force, Tsar Asen II of the revived kingdom of Bulgaria, who had his own designs on Constantinople, and who defeated and blinded Theodore Angelus at the Battle of Klokotnica on the river Marica in 1430. Epiros retained its independence until it became part of the rising kingdom of Serbia in 1337, but only Nicaea was left in a position to claim the inheritance of the Byzantine Empire.

The Latin Empire had already suffered its own defeat at the hands of the Bulgarians at the Battle of Adrianople in 1205 at which Baldwin of Flanders had been taken prisoner. The loss of Thessalonica was a further blow, and it soon became unable to defend itself. The empire in Nicaea was already conducting itself as the legal government of Byzantium, negotiating with foreign powers and keeping up all the trappings of an imperial court. In 1261 the forces of Nicaea entered Constantinople unopposed and brought the Latin Empire to an end. The beneficiaries, though, did not include the Lascarids: three years earlier Michael Palaeologus, a successful general, had seized power during a regency, so it was Michael VIII who was crowned in the Ayia Sophia as emperor of Byzantium.

Byzantium was restored, but with a very different character. It was no longer really an empire: it was geographically reduced to the

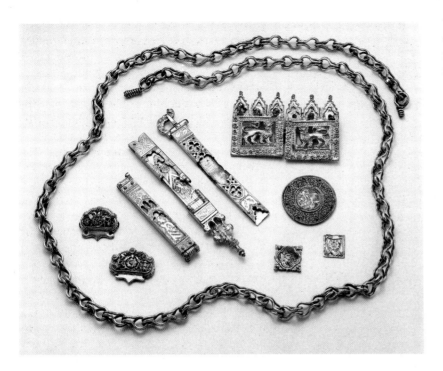

79 **79** Treasure of silver-gilt personal ornaments found at the castle of Chalcis, Euboea, Greece.

that a collection of silver-gilt jewellery was deposited at Chalcis, which guards the crossing to the Greek mainland. Of Venetian manufacture, it has some classical touches, such as a female bust or personification on a belt mount, and several of the pieces are decorated with filigree and enamelling.

One significant area which passed from Frankish to Byzantine hands was the southeast corner of the Peloponnese, or the Morea, as the Franks called it. The de Villehardouin family, princes of Achaia, were forced to hand over in ransom the three castles they had built at Maina, Mistra and Monemvasia. Monemvasia, the prominent rock on the east coast of Greece, was of obvious strategic importance to Byzantium, but Mistra, in the foothills of the Taygetus mountains close to ancient Sparta, was to become even more significant. A town grew up on the steep slopes below the castle, and became the seat of a bishopric. As it grew more important the emperors appointed its rulers from families close to the throne, the

eastern parts of Greece and the Balkans and the western parts of Asia Minor, and all other national groups except Greek had fallen away. This limitation, though, was to give a political and cultural cohesion to the Palaeologan period. Although the high point of the Crusader states had passed – the Latin Kingdom of Jerusalem was finally brought to an end in 1291 by the efforts of a new power, the Mamluk dynasty in Egypt – much of Byzantine territory still remained in Latin hands. Cyprus, for instance, was never to be recovered by Byzantium, although Byzantine and Frankish forms of art and architecture continued to co-exist for centuries. Other areas passed to and fro between Byzantine and Latin control. The island of Euboea – or Negroponte, to give it its Frankish name – had been part of the Venetian share in 1204, but was recovered for Byzantium by the naval operations of Michael VIII. From 1385 to 1470 it was again in Venetian hands, and it was presumably during this time

80 Cream-glazed red-ware dish with sgraffiato decoration, 12th century. From the Aegean Sea between the northern Sporades and Mitylene.

Cantacuzeni, and eventually from junior members of the Palaeologan house. For its two hundred years of existence Mistra was to enjoy a more prosperous life than Constantinople itself, a fact reflected in the many churches and private houses which dot its slopes, and in the wall-paintings in those churches, which are some of the best examples of Palaeologan art.

In the city of Constantinople there could only be a partial recovery. The city was simply too big for its population and urban life was given up in large parts of the city, which reverted almost to open countryside. The Great Palace was already in decay, and the emperors built a new palace, the so-called 'Tekfur Sarayı' in the Blachernae quarter alongside the land walls. This is still standing: its plan, basically a rectangular block, is western in origin, but the three-storey façade has been given the red and white brick and stone pattern characteristic of late Byzantine architecture. In the palace court life was kept up with inadequate resources. In the twelfth century, pottery made in the sgraffiato technique would have been bought by the middle levels of society; by the fourteenth century the emperor himself was reduced to serving his guests off earthenware, and disillusioned foreign visitors reported seeing paste jewellery and gold vessels revealed as painted glass.

Yet from this shattered economic base there rose one of the most brilliant of the Byzantine renaissances. Within a few years of the recovery of the city the Ayia Sophia was graced with one of its finest works of art, the mosaic panel of the Deesis in the south gallery. This iconographic type had become popular during the Macedonian Renaissance. It shows Christ flanked by St John the Baptist, whom the Byzantines called Prodromos, the Forerunner, and the Virgin, who as representatives of the old and new dispensations are interceding

81 View of Mistra, in the southern Peloponnese, Greece. The three-storey palace, built around a large courtyard, is one of the most impressive Byzantine secular buildings to have survived.

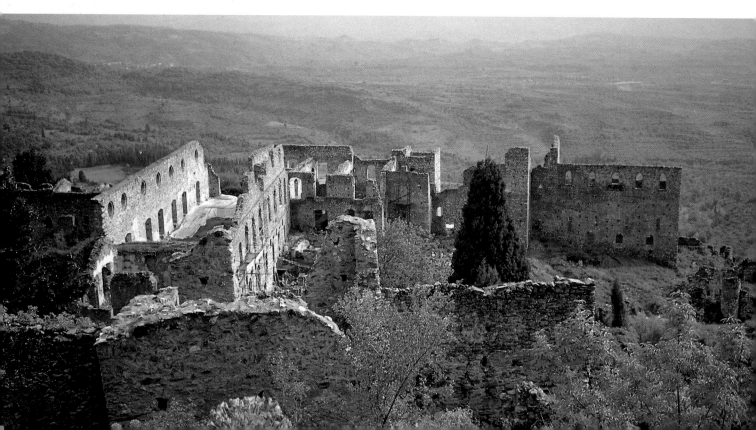

with Christ for mankind. Byzantine art of the Palaeologan period is just as formal as in any preceding period, but the figures are treated semi-naturalistically and a restrained emotion is allowed to break through. The faces on this Deesis are finely drawn, but express a grave sympathy with the plight of mankind. The same qualities speak through an icon of St John the Baptist. As on the Ayia Sophia mosaic, only the windswept hair recalls the locust-eating saint of the desert; this St John has been suitably tamed to fit into a Palaeologan home, for this small icon was presumably intended for private devotion rather than for church use.

Icons, of course, carry no dating evidence with them; the best stylistic parallel for this icon is with the early fourteenth-century mosaics and frescos of the Church of the Theotokos Pammakaristos, the Virgin All-blessed, in Constantinople, now the Fethiye Camii. There were still families and individuals wealthy enough to commission whole schemes of church decoration. It was the Pammakaristos where Alexius Comnenos was buried; it was repaired and a new extension, or parecclesion, was built by members of the Comneni family. The monastery church of St Saviour in Chora, now the Kariye Camii, stands as its name 'in the country' implies, at the very edge of the city by the land walls. It was extended and restored between 1315 and 1321 by Theodore Metochites, chief minister, Grand Logothete, to the emperor Andronicos II. Theodore Metochites was a scholar and poet, and the centre of a cultural circle. He has left his own account of his considerable wealth, which is borne out by the splendid mosaic cycle with which he decorated the church and its new narthex. The life of the Virgin is given especially full treatment, from her first steps to the Dormition, with an explosion of bright colours and narrative details. Even more remarkable than the mosaics are the paintings of the Last Judgment

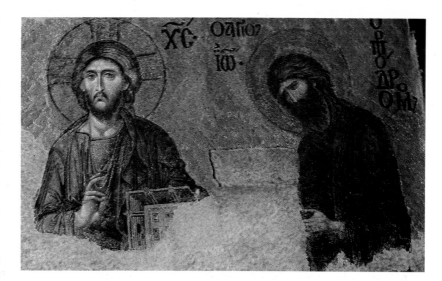

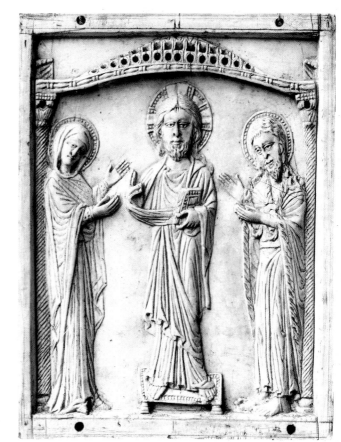

82, 83 Two images of the Deesis: **82** (*above*) is a detail from the mosaic panel in Ayia Sophia, late 13th century; **83** (*left*) is a 10th-century ivory from the Macedonian Renaissance. St John the Baptist, the cousin of Jesus, and the Virgin both have an emotional link with the central figure of Christ, in addition to their theological significance.

in the new parecclesion: an angel swirls across the vault rolling back the scroll of heaven, and in the apse Christ in a white star-studded mandorla outlined against the deep-blue sky braces himself to haul Adam and Eve out of their sarcophagi amid the shattered debris of Hell. The church has also retained much of its sculptured decoration, but it has not retained the icons, which would have hung on the iconostasis; it is known that an icon of the Virgin was broken by the Turks in 1453. However, an icon of St Peter recently discovered on the back of a seventeeth-century icon of Christ, upside down and covered by whitewash and blackened varnish, may possibly have been one of them; the panel had been cut down to take the later image. The identification of St Peter is by appearance, a middle-aged man with a chunky white beard, and by the text on the scroll from the First Epistle of Peter, which is an exhortation to purity which might suggest a monastic audience. Its craftsmanship and the quality of the gilding proclaim it as a luxury object, and details of style – the pale colours of drapery already noticed on the St John, the firm treatment of the face – place it in early fourteenth-century Constantinople, perhaps from the workshop of the artist of the Chora.

In his donor mosaic Theodore Metochites presents his church to Christ wearing a huge green and white turban, as if he already sees himself more as the Grand Vizier to the Ottoman Sultan than as the Grand Logothete to the emperor of Byzantium. The Mongol invasions of the mid-thirteenth century had stirred up the Seljuk states of Asia Minor, and the sudden emergence from among them of the aggressive Ottoman dynasty faced Byzantium with an enemy which it could not hope in its reduced state to defeat. The emperors of Nicaea were distracted by the restoration of 1261 into waging war against the Latins in Greece, so their eastern defences were allowed to lapse. Most of the land of Asia Minor was in

Turkish hands by 1300, and the cities fell one by one in the next few decades; Nicaea was lost in 1329. By the 1350s the Turks had a foothold in Europe at Gallipoli, and it was clearly only a matter of time before they picked off the last territories of Byzantium and the city itself.

The only help possible could come from the west, and from 1261 onwards Byzantium made a series of increasingly desperate appeals; in 1399 Manuel II went on a personal tour of European capitals, spending Christmas with Henry IV at Eltham Palace in London, in a vain attempt to rally support. The problem was and remained the schism between the Churches. As early as 1274 Michael VIII accepted a scheme of union at the Council of Lyons, which included his submission to the Pope and acceptance of the *filioque* clause (p. 48), but opposition to this ran so high that it was repudiated on his death. Proclamation of the union on these terms remained the condition of help from the west, a price which Byzantine was not prepared to pay.

The Byzantine church was riven internally as well as externally. Monks living in the monastic communities on Mt Athos in northern Greece had been developing methods of silent prayer – *hesychia*, silence, gave them the name of Hesychasts – based on the writings of an eleventh-century mystic, St Symeon the New Theologian. Their practices provoked fierce debate, which was finally settled in favour of the Hesychasts at a Church Council of 1351. As usual in Byzantium, everyone joined in a religious controversy, including the emperor, but problems were compounded by a struggle for imperial power. Byzantium in the mid-fourteenth century was in a state of civil war, the army commander, the Grand Domestic John VI Cantacuzenos, having declared himself emperor during the regency of the legitimate Palaeologan John V. It was another round of the old struggle, the provincial aristocracy versus the capital, but divisions

84 St John the Baptist, early 14th century. The icon is painted in a range of delicate colours applied in thin transparent layers, which increases the softness of the effect, but the painting is outlined against a rich gold background, and the extension of the painting on to the raised edge of the icon brings the saint forward out of the frame towards the worshipper.

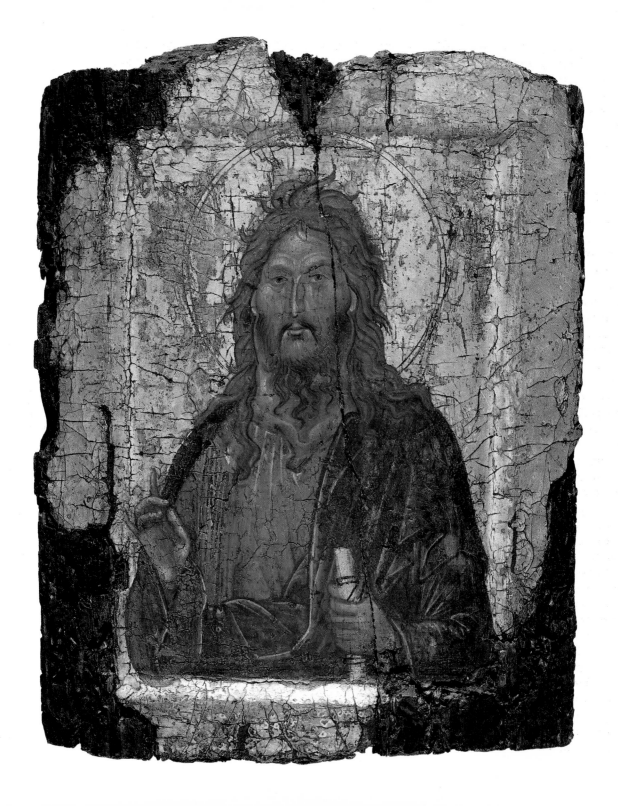

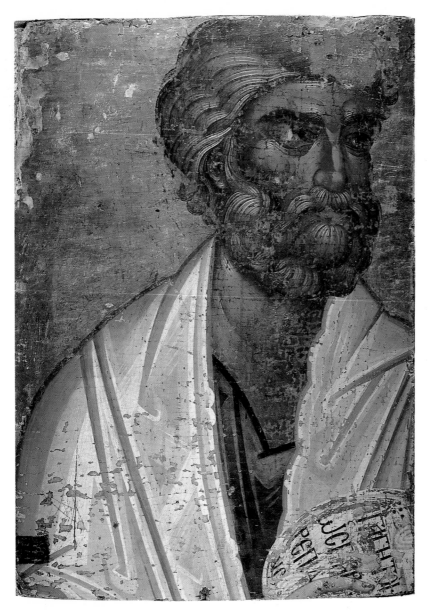

85 Icon of St Peter, early 14th century. Cut down at a later date to take an icon of Christ on the back. The inscription is from I Peter 2.11 and translates: 'Beloved, I beseech you as aliens and exiles to abstain from the passions of the flesh that wage war against your soul'.

were deepened this time because of the religious dimension – Cantacuzenos took up the cause of the Hesychasts – and because the people had suddenly found a voice. Mass movements in Byzantium rarely did more than demonstrate in the Hippodrome and topple the occasional emperor. This time, however, the people had leaders, so-called zealots. They were organised in several cities, and they could claim to be supporting the legitimate dynasty, and legitimate religious practice, against Cantacuzenos and the Hesychasts.

Popular feeling came to a head in Thessalonica. The city had become increasingly independent of imperial authority in the thirteenth and fourteenth centuries, and it was proud of its own local traditions. There was considerable wealth in the city, which is reflected not only in church decoration but in new church building: St Catherine's, the Holy Apostles, St Nicholas Orphanos. The style of these churches was taken up in the rest of Macedonia, now part of the expanding Serbian Empire, and the Serbian kings also employed Greek artists to paint their new Byzantine-style churches.

While some of its inhabitants could afford patronage on this scale, Thessalonica, a port city set amid the ravaged countryside, had many poorer inhabitants, and was seething with social unrest. In 1342 the zealots threw out the Cantacuzene administration and ruled the city themselves for seven years independent of imperial authority. It was a bitter and bloody episode. The aristocrats lost their goods and were lucky to escape with their lives, but it can also be seen as a genuine and unique attempt in Byzantium to run local government on semi-communist principles.

Weakened by internal strife and isolated from the Christian west, Byzantium was ill-fitted to withstand the pressure from the Ottoman Turks. She had not sought common cause with the other Balkan powers, so they

were picked off one by one. In a battle at the river Marica in 1371 the Turks seized Macedonia from Serbia, and in 1389 followed it up with their victory at Kosovo, on the Field of the Blackbirds, a battle which ended Serbian independence and still lives in the national memory. Bulgaria was similarly reduced in 1393 with the capture of its capital, Trnovo. The emperor of Byzantium had been a vassal of the Sultan since 1373 and could not expect long to survive his neighbours. Constantinople was blockaded in 1397, but was unexpectedly saved by a sudden attack on the Turks' eastern front by Timur (Tamurlaine) and his Mongols, on the last stage of their victorious rampage through Asia. The Sultan Bayezit was obliged to raise the siege and cross into Asia Minor, where he was taken prisoner at the Battle of Ankara in 1402. The resulting dynastic confusion delayed the Turkish advance in Europe for fifty years.

Byzantium used the respite for a final attempt at church union; the emperor himself led the delegation to Italy. A head of John VIII
86 on a medallion by Pisanello shows one of the last emperors of Byzantium, 'Basileus and Autocrator of the Romans', through western eyes: ironically, not even the curious high pointed hat he is wearing is distinctively Byzantine, but is also used on western engravings of the 'Grand Turk', suggesting that westerners had given up trying to distinguish heretics from infidels. A famous remark circulating in Constantinople before its fall also points to the significance of headgear: 'Better to see the turban of the Turk ruling in the midst of the City than the Latin mitre'. Church union was agreed in principle at the Council of Florence in 1439, but John VIII had even less chance than Michael VIII of imposing it on his still defiant subjects, and it did not lead to the hoped-for material help from the west.

Byzantium had to meet the final attack alone. The story of the fall of Constantinople has been stirringly told by eye-witnesses and by the doyen of Byzantine historians, Sir Steven Runciman. The scale of the odds (eighty thousand men and hordes of irregulars against fewer than seven thousand manning fourteen miles of wall); the inevitability of the outcome, which was perfectly apparent to those involved; the continuing hope of relief while knowing this was hopeless – all these still grip the imagination. The Sultan, Mehmet II, was a young man alive to the historic significance of his opportunity and determined to seize it. His preparations had been meticulous and imaginative; he had personally commissioned a colossal cannon capable of throwing a ball of twelve hundredweight, and had already used cannon from his new castle at Rumeli Hisar to command the Bosphorus approach to Constantinople. Constantine XI had also prepared himself to meet the occasion. He came to Constantinople in 1449 with a high reputation from his years as Despot of Mistra, and in the years that remained worked tirelessly to prepare the city's defences.

The siege began on 6 April 1453. The main attack came as expected on the great Theodosian land walls; the huge cannon blasted great holes, but the citizens managed to keep them filled with rubble. So long as the mole across the Golden Horn could be held, the harbour walls were not under direct threat, so it was a decisive moment when the Sultan brought his ships into the Golden Horn by hauling them on a tramway built over the hill at Galata. Mehmet II was well aware of the importance of morale: the ships were brought down the hill with sails hoisted and oars beating as though they were at sea.

By the last week in May the defenders had come to the end of their strength. The day before the final attack crowds gathered in the Ayia Sophia, though they had boycotted it in the last few months since the church union had been proclaimed. Now at last these divisions ceased to matter. The Sultan launched

86 Bronze medallion of John VIII Palaeologus, made by Pisanello in 1438. This was the first cast Renaissance medal made in Italy.

87 View of Istanbul (Constantinople) and Galata in 1537, from the Beyan-ı Menazil-i Sefer-i Irakeyn (descriptions of the halting stations during the Irakeyn campaign), painted by Matrakçı Nasuh for Süleyman the Magnificent. (Istanbul Üniversite Kütüphanesi).

his decisive attack during the night before 29 May, and just before sunrise the Turks broke through a small postern gate near the Blachernae. The city had fallen and with it the empire; Constantine XI the last emperor died in the fighting and his body was never found. The dead numbered 4,000, the prisoners were said to number 50,000. Mehmet II allowed his soldiers time for looting, as prescribed in Islam, but made it clear this should not include the destruction of buildings, and some churches were left untouched for the future use of the Christian population. He himself, as he set about building an Islamic city amid the ruins of Constantinople, was well aware of what had been lost. As he wandered from the Ayia Sophia through the Great Palace, it was said that he murmured the words of a Persian poet: 'The spider weaves the curtains in the palace of the Caesars; the owl calls the watches in Afrasiab's towers'.

Acknowledgements

A general work on Byzantine studies is bound to draw prodigally on the work of more Byzantine scholars than it is possible to acknowledge, either here or in the Further Reading list.

I should particularly like to thank David Buckton and Geoffrey House, who at a busy time have read the draft text and made careful observations and comments. They are of course not responsible for any remaining errors or inaccuracies.

The passages in the text relating to icons (pp. 61, 65–6) owe much to the work of Robin Cormack of the Courtauld Institute. I am happy to acknowledge his continuing interest in the national icon collection in the British Museum.

The text has been typed by Pat Terry. Carole Morris and John Cherry of the Department of Medieval and Later Antiquities have laboured to produce the photographs and new photography has been done by John Heffron, Peter Stringer and Miles Tubb of the British Museum Photographic Service. I am very grateful to them all.

At British Museum Publications Ltd I should like to thank Celia Clear, and especially Jenny Chattington, the editor, for her considerable patience.

My colleagues in the Education Service and many other friends have given redoubtable moral support throughout the project; among those who have burdened themselves additionally to enable me to finish it, I am particularly thankful to Charlotte Roueché, my tireless co-editor of the *Bulletin of British Byzantine Studies*.

Further reading

Peter Brown, *The World of Late Antiquity* (London 1971).

Robin Cormack, *Writing in Gold: Byzantine Society and its Icons* (London 1985).

Judith Herrin, *The Formation of Christendom* (Oxford 1987).

Richard Krautheimer, *Early Christian and Byzantine Architecture* (Harmondsworth, new edn 1975).

Cyril Mango, *The Art of the Byzantine Empire 312–1453* (Englewood Cliffs, New Jersey, 1972).

Cyril Mango, *Byzantium: the Empire of New Rome* (London 1980).

George Ostrogorsky (trans. J Hussey), *History of the Byzantine State* (Oxford 1968).

Steven Runciman, *The Fall of Constantintople 1453* (Cambridge 1965).

Philip Whitting, *Byzantium, an Introduction* (Oxford, new edn 1981).

Index

Photo acknowledgements

The author and publishers wish to thank the following for permission to reproduce their photographs:

British Library 53
Nicola Coldstream 55
Director-General of Antiquities and Museums of the Ministry of Culture and Tourism, Turkey 45, 87 (photos Reha Güney)
Geoffrey House title page, 3, 29, 54, 56, 82
Patsy Vanags 81

Nos 18, 24, 39, 40, 74, and the inside back cover are the copyright of the author; all other illustrations have been provided by the Photographic Service of the British Museum.